MARSHA TAYLOR

a heart after God

A STUDY OF BIBLICAL WOMEN
TO CULTIVATE DEEP CHARACTER

A Heart After God: A Study of Biblical Women to Cultivate Deep Character
Copyright © 2024 by Marsha Taylor

Published by Lucid Books in Houston, TX
www.LucidBooks.com

ISBN: 978-1-63296-708-4
eISBN: 978-1-63296-709-1

All rights reserved. No part of this publication may be reproduced, stored in a retrieval system, or transmitted in any form by any means, electronic, mechanical, photocopy, recording, or otherwise, without the prior permission of the publisher, except as provided for by USA copyright law.

Special Sales: Most Lucid Books titles are available in special quantity discounts. Custom imprinting or excerpting can also be done to fit special needs. Contact Lucid Books at Info@LucidBooks.com

Unless otherwise indicated, scripture quotations are taken from the ESV® Bible (The Holy Bible, English Standard Version®), copyright © 2001 by Crossway, a publishing ministry of Good News Publishers. Used by permission. All rights reserved.

Scripture quotations marked (NLT) are from the Holy Bible, New Living Translation, copyright © 1996, 2004, 2015 by Tyndale House Foundation. Used by permission of Tyndale House Publishers, Inc., Carol Stream, Illinois 60188. All rights reserved.

Scripture quotations marked (NET) are from the NET Bible® copyright ©1996, 2019 by Biblical Studies Press, L.L.C. http://netbible.com All rights reserved.

Scripture quotations marked (TLB) are from The Living Bible copyright © 1971 by Tyndale House Foundation. Carol Stream, Illinois 60188. All rights reserved.

Scripture quotations marked (AMP) are from the Amplified Bible; Copyright © 2015 by The Lockman Foundation, La Habra, CA 90631. All rights reserved.

Scripture quotations marked (The Message) are from The Message; Copyright © 1993, 2002, 2018 by Eugene H. Peterson

With a Thankful Heart

To my husband, David
who is my rock and constant source of encouragement and love –
thank you for always supporting me and making me laugh.

To my family
Catherine & her husband, Will, and Caroline & her husband, Brennen,
who bring joy and fun to my life – thank you for listening, supporting, and loving me.

To my friends
Maureen, Cindy, Jennifer & Karen –
thank you for your commitment to walk through life side-by-side, in good and bad times.

To the women who worked through A Heart After God prior to publication
thank you for your encouragement, wisdom, and refinement.

To my Lord and Savior, Jesus Christ
may my life be an offering of gratefulness and praise for all You have done for me;
may Your name be lifted high, and may You be glorified in everything.

Soli deo gloria.

How A Heart After God is Designed:

A Heart After God is designed for daily study in God's Word. Each lesson will cover a specific woman of the Bible, and we will learn their stories directly from scripture. Each lesson is divided into five different days of study, and a short conclusion section. Ideally, you should complete one lesson per week. My desire is for you to search your Bible to find deeper meaning and personal application of the truths they hold. The questions are designed for you to answer with your own thoughts and ideas about the scripture, and not simply write the verse verbatim from your Bible.

The workbook study is estimated to take you approximately 20-40 minutes for each day's lesson or one to two hours for the entire lesson. Questions are written using the English Standard Version (ESV) of the Bible. If you are using another version and do not understand a question or the answer, please check the ESV for clarity. I have written the study in a conversational style, which may be different than other studies you have done, as I want each reader and student to feel they have someone by their side as they are studying.

I believe that the time you spend in God's Word will be greatly beneficial. Hebrews 4:12 tells us that His Word is living and active, so each time you look into scripture, God is going to speak to your heart to bring you encouragement, correction, or instruction. Oh friend, that can be a specific word about something He wants to do or change in your life, something about the situation or circumstances you are facing, something about His character and His love for you, or something altogether new! Whatever it is He wants to say, it is thrilling to hear the very words of God speaking to your soul!

So, dig in! Enjoy the depth of each verse you look up. My desire in writing this study is to take you into the Old and New Testament to see for yourself that God is the same yesterday, today and forever and to learn how beautifully all scripture works together to glorify God and point us to His Son, Jesus.

As for commentaries, do your best to complete the lessons without consulting a commentary for assistance. Commentaries can be excellent tools for additional study, but it is more meaningful when you can find the answer in His Word alone. Pray and ask God to help you find the answer to a question you are struggling with or is challenging to you. God wants you to learn from Him and His Word, and it is thrilling when He teaches you.

Resources

To enhance your study, there are teaching videos that accompany each week's lesson. If you are able to work through this book in a group setting with your friends or at your church, discussion questions are included in this book, beginning on page 149.

Videos can be downloaded at www.freshsurrender.org.

For Leaders

If you are interested in leading a group in your home, community, or church, please visit www.freshsurrender.org for additional materials to download free of charge.

Small group discussion questions, listening guides to accompany the video teaching, and administrative materials to help facilitate a class are also available on the website.

If you are interested in teaching the material rather than using the video content and facilitating a group, please know that is thrilling to me. I am praying that teachers will find the workbook content complementary to their teaching.

SPECIAL DISCOUNT

Chapter Videos

Interested in watching the video series to enhance your study?

Marsha has recorded a video teaching to accompany each lesson, to be viewed following each chapter.

If you are interested in purchasing the video series, please visit **www.freshsurrender.org**.

Please use the code "heart" to receive the video series at a deep discount.

Table of Contents

Lesson 1 .. 9
Rahab…a heart that believes

Lesson 2 .. 29
Hannah…a heart that prays

Lesson 3 .. 49
Ruth…a heart that loves

Lesson 4 .. 71
Esther…a heart that waits

Lesson 5 .. 91
Deborah…a heart that leads

Lesson 6 .. 111
Martha & Mary of Bethany…a heart that worships

Lesson 7 .. 129
Mary, the Mother of Jesus…a heart that surrenders

Questions .. 149
for Group Discussion

LESSON ONE

Rahab
a heart that believes

A HEART AFTER GOD

What does it truly mean to believe? According to many, it is simply trusting something to be true or someone to exist. We choose to trust or not trust these things or people every day. When you see a news report or hear of the Loch Ness Monster or Santa Claus, do you believe all that you see or hear? I assume there are some things that are easy to draw in your belief, while other influences or people are met with skepticism.

When thinking of a heart that pleases God, I think it has a deeper meaning than just belief. It is an attitude of the heart – one that is willing to believe God is who He says He is, and that Jesus, as His only Son, died for the penalty of our sins. It is a heart that believes God will remain true to all His promises and has a plan and a purpose for His children. It is a heart that dies to self in abandon to following His will and acting in that belief in gratitude for all He has done. This is the believing heart we should all want to be cultivated in us.

If you look into the book of Joshua, beginning with Chapter 2, you find the story of Rahab. If you don't know Rahab's story – you might be surprised that she is one of the women we are studying, because she isn't a shining example of purity and virtue. As a businesswoman living in Jericho, Rahab was an innkeeper and a prostitute. She was an Amorite woman, and if she followed the religious practices of her nationality, she also engaged in worshipping idols. Since many times personal names found in the Bible described character, I think that Rahab was a pretty tough woman who didn't let many people take advantage of her as her name means "insolent and fierce."

So, as we start into Rahab's story, I think it is important that we first review a bit of background of the history of Israel. This background will help us better understand Rahab and learn from her story. To get started, we'll start with the book of Genesis.

Day One
Introduction & History

In Genesis, God promised a land to Abraham – a land where God would establish and provide for His chosen people. This is the land we call "Israel" today. Even though God gave this special "promised land" to His people to inhabit, it proved difficult for them to abide there, as they often fell into rebellion against God. As a punishment for their stubbornness, idol worship, and turning their backs on God, He would allow them to be taken captive by a warring nation and taken from their land to serve as forced labor in the conquering land. After years in exile, the Jews would be freed and allowed to return to their land, full of renewed gratitude to God, only to fall back into the pattern of rebellion and captivity over and over again.

Read Genesis 17:1-8, which records God's covenant with Abraham.
What does God promise to Abraham?

Read Genesis 26:1-5.
What do you see about God's faithfulness to fulfill His covenant to Abraham though his son, Isaac, once Abraham had died?

While we are not going over all this history, it is important to know the events leading up to the book of Joshua. You may recall the story of Joseph and his brothers selling him to a traveling caravan, which is also recorded in the book of Genesis. Through many years and a long series of events, Joseph eventually finds himself as an important advisor for the Pharoah in Egypt. To prepare for a coming drought, God foretells Joseph, through

dreams, to stockpile grain for the time when food is scarce. Joseph's family eventually comes to Egypt looking for food, which Joseph is able to provide. It is at this moment in history, that the people of Israel leave the promised land and settle in Egypt. (See Genesis 37-50 for the complete story of Joseph and the migration of Twelve Tribes of Israel to Egypt.) Over the course of the next 430 years, the people of Israel thrived and grew greatly in number.

Eventually, the stories of Joseph were forgotten, and new leaders ruled in Egypt. Fearing the potential power of God's children, Pharoah forced them into heavy oppression, forcing them to work, and driving them into slavery. Hearing the cry of His children under this great oppression, God raises up a deliverer to lead them out of captivity and back into their home - the promised land.

Read the call of Moses as recorded in Exodus 3:1-12.
Once again, we see that God's plan included the inheritance of a land.
What do you learn of God's promises as given to Moses (v. 8)?

The epic story of God's deliverance of His children from bondage in Egypt through Moses is recorded in Exodus by the parting of the Red Sea, and they started the journey back to the land promised to Abraham and his people. But did you notice in Moses' call that the land was now inhabited by several different people groups? To move back into this promised land meant conquering these tribes. So, twelve spies were sent into these cities to assess how best to take their land back. Ten saw the giants and the obstacles and two believed in the power of God to deliver.

The spies' reports and the people's reaction are recorded in Numbers 13:25-14:12.
Summarize what you learn below.

We have looked back at a good amount of history, and specifically at God's promises to His people about this land. God has been clear beginning with the promise He made to Abraham that the land of Canaan was their inheritance. Caleb and Joshua believed these promises, and despite the obstacles, trusted that God would deliver on those promises.

Why do you think that the Israelites doubted the promise and feared moving forward to take their land?

Read Deuteronomy 7:9 and record what you learn about God's faithfulness.

God's children did not believe in God's ability to fulfil His promise, and as punishment, He prohibited everyone over the age of 20 from entering the land that God had given them, and they wandered in the wilderness until the generations died – for 40 years. But, because of the faith of the two spies who believed that God would do as He promised, Joshua and Caleb became the leaders of the new generations and were given the privilege of leading them into the land promised.

Now in history, we come to Rahab's story. Moses has died, as have the generation of disbelievers. The Jewish nation has been wandering in circles for 40 years, and as Joshua steps into command, it is time to move.

Day Two
Rahab's Story

Our stage is now set. Joshua is poised to lead the people forward to the land promised thousands of years before. The first city that was to be conquered was Jericho, a fortified city with a big wall built around it for protection. Needing to assess the city's defenses and learn of its weaknesses, Joshua sends in spies, and they encounter Rahab.

Rahab's home was located on the wall of Jericho, and while it was a place for prostitution, it was also a general place of lodging for travelers and would have been a particularly good place for a spy to gather facts without being too obvious.

Skim Joshua 2:1-9 to read the beginning of Rahab's story for yourself.
Look at verse 9. What does Rahab say about the land God had promised to His children?

When the authorities came to Rahab's home looking for the spies, she lied to the authorities and kept the spies safe from harm, at significant risk to herself. In return for saving the lives of the spies, Rahab asks to be spared when her city is destroyed.

Read Joshua 2:18-21 and record the instructions the two spies gave to Rahab
in order ensure her safety when the city was seized.

It is amazing to me to see the declaration of Rahab about God. Consider who she was – a prostitute and a woman from a community of idol worshippers. And yet her faith in the God of Israel, her knowledge of Him and the works He has done, and her certainty He would deliver the land into the hands of Joshua was remarkable.

What does she declare according to Joshua 2:11b?

The day of the Battle of Jericho arrived, the men blew trumpets, and marched around the city, witnessing the power of God as He brought the Wall of Jericho down. There was utter destruction and chaos in the city that day.

From Joshua 6:22-25, what happened to Rahab on that day and why?

Not only do we see the story of Rahab recorded in the Old Testament book of Joshua, but she is also remembered in the New Testament.

What do you learn from the following passages?

Hebrews 11:30-31:

James 2:25-26:

Matthew 1:1 & 5:

This woman of questionable character is not only celebrated in the Old Testament, but she is used as an example of faith to us in the New Testament. And most remarkably, she is listed in the lineage of Jesus. While we will delve into the character of Rahab in our next section, take time to reflect on God's acceptance of this amazing woman before you close your workbook for the day. While some people may have seen a woman in a disrespectable job and a shameful position, God saw the woman who would be the great, great, great grandmother (many times removed) of His Son. And He recorded her name forever in His Word. God saw her heart. While her actions may have been soiled and sordid, God saw more. He saw the beauty of a heart that had been redeemed.

Record any reflection notes below:

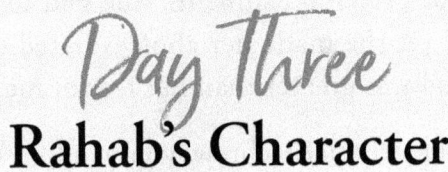
Rahab's Character

There are some things we can learn from scripture about Rahab, and there are other conclusions we are going to make about her character in this section by reading in between the lines and drawing basic conclusions on what we know of human nature. The first thing we know is that she was a prostitute.

Already, several times in our study, Rahab's occupation has been mentioned. Just seeing the word prostitute could cause us to draw conclusions about Rahab based on that one word alone. Instead, let's focus today on the word was. Rahab WAS a prostitute. BUT God has the power to transform lives. What was true at one time, now lies in the past. Don't you just love those two little words, "but God?"

What encouragement do you find in Hebrews 8:12?

Let's look at her declaration again from Joshua 2, printed below from the Living Bible:

> *"I know perfectly well that your God is going to give my country to you," she told them. "We are all afraid of you; everyone is terrified if the word Israel is even mentioned. For we have heard how the Lord made a path through the Red Sea for you when you left Egypt! And we know what you did to Sihon and Og, the two Amorite kings east of the Jordan, and how you ruined their land and completely destroyed their people. No wonder we are afraid of you! No one has any fight left in him after hearing things like that, for your God is the supreme God of heaven, not just an ordinary god."*

Can you put yourself into Rahab's shoes as she is making this statement? I am sure she is terrified! She is certain that her city is going to be destroyed, and she will either be killed or taken into slavery. And to make matters worse, officials are knocking at her door asking

about the men seen earlier at her establishment! She had to be quivering as she lied to them to keep the spies safe; yet she made her choices based on what she believed about Jehovah God. Her fear of God was greater than her fear of men.

If you were to read this in the original Hebrew, you would see that Rahab uses the most revered name of God, Yahweh, which is the name of God that speaks of His covenant and speaks to a personal relationship with Him. It is tender and intimate. And this was the name Rahab chooses to use when speaking of Him.

What a beautiful statement! Rahab acknowledges that God is supreme over all, and she recognizes her need for salvation, believing her death is imminent as the seize of her city, Jericho, is at hand. By using this particular name of God, she shows the spies her heart, and they agree to save her life. And we see in Joshua 6, she was welcomed into the Israelite family for the rest of her life as a member of their family.

In Rahab, we see her strong belief that God had the power to save her.

According to Joshua 2:18, what item was Rahab to tie from her window to serve as a sign for her protection during the siege? (Name the item and its color.)

Read the following passages.
Do you see any significance between this color and salvation?

Exodus 12:7 & 13:

Hebrews 9:22:

Ephesians 1:7-8:

Such beautiful symbolism – a scarlet cord was the means by which Rahab's life was saved, just as the crimson blood shed by Jesus Christ is the way that we receive a covering for our sin and find eternal salvation in Him. Just as Rahab's belief in God's ability to save her required an action (tying the cord to the window), so we too must put our belief in God into action in order to find salvation – we must accept His gift of salvation made through His Son, Jesus, and call on Him to be our Savior. (If you would like to read more specifically how to move from belief in Jesus to salvation in Him, please read the section titled "How to Know Jesus" at the end of this chapter.)

Oh friend! God has the power to save Rahab, and He has the power to save you and me! Maybe you are in a terrible situation, and you need rescue. Maybe your marriage is on the brink of falling apart. Maybe it is a situation that seems impossible to find your way out of, or an argument that seems will never have resolution. I am here to tell you – you can trust God to save you, too. Just as He did for Rahab.

Not only did Rahab experience God's salvation, but she also saw His power to transform her life. We have already seen from our lessons this week that Rahab lived with the Israelites for the rest of her life following the destruction of Jericho. In fact, her family tree is pretty amazing – she married a Jewish man named Salmon and gave birth to a son named Boaz. Boaz married a woman named Ruth, and they gave birth to a son named Obed. Obed had a son named Jesse, who had a son named David, who became king of Israel and was in the line of Jesus Christ.

Rahab's name is listed in scripture in the lineage of Jesus, as well as being listed among the faithful saints in Hebrews 11. She went from harlot to revered saint all because of the power of God to transform. Never underestimate God's power to transform lives and hearts. Maybe you have something in your past, and you need to know that God can transform you as well. Maybe right now, you just aren't walking with Him in the way you would like. Maybe you're hanging onto a sin, or an attitude, and you need to let go. Maybe it is your life that you need Him to transform or your heart that you need Him to change. Trust Him. Believe that His love for you and His power in your life can transform. It certainly changed Rahab.

And just because we all love a good love story, tradition holds that her husband, Salmon, was one of the spies that she hid! (This isn't recorded in scripture, but what a sweet story if it is true!)

Day Four
A Deeper Understanding of Belief

According to Elizabeth George, "[Rahab] would probably try to explain that there is faith – and then there is faith! There is faith in the truth and belief in the Word of God, the Bible, but then there is faith-in-action. Rahab heard about God and believed in Him. But her faith didn't stop there. No, Rahab then went to work, took the risk, and made the choice to save the spies. Rahab lived out what the New Testament apostle James wrote, 'Be doers of the word, and not hearers only, deceiving yourselves…. what does it profit, my brethren, if someone says he has faith but does not have works? … Faith by itself, if it does not have works, is dead.' James 1:22, 2:14, 17)."[1]

So, what is the relationship between faith and works? Can we merely have an intellectual knowledge of who Jesus Christ is and be saved? The answer is no. We must surrender to God and trust the work of Jesus on the cross for our salvation. That type of faith breathes life into our souls, and our response to His grace produces good works – or action.

However, if we try to only rely on our good works (for example, church attendance, giving to the needy, going on mission trips, being kind to others, etc.) as our way of pleasing God and entering Heaven when we die, then we are going to find our works are lacking. Salvation is solely based on Christ's work on the cross as paying the penalty for sin and has nothing to do with anything we try to do to earn God's favor. Remember, God doesn't allow good people into Heaven, He only allows the holy ones; and holiness is found through accepting forgiveness by the cleaning blood shed by Jesus on the cross.

No one can come to a saving faith in Jesus Christ and remain the same. A true, dynamic faith involves our mind, our emotions, and our will – the mind understands the truth; the heart desires the truth; and the will acts upon the truth. True, saving faith will lead to action.

Record the words of James 1:22 below:

Before we get too deep into the subject of our works, it is very important to note that our salvation is not dependent upon our works. Salvation is through grace alone, which is a gift of God that you and I have absolutely no hand in giving. Christ completed the work on the

cross, and we cannot add to it in any way. But our good works are important because they are evidence to the work of God in us and prove that a change has taken place in our lives.

Personalize the following verses by recording them in the space below and inserting your own name:

Ephesians 2:10

Titus 2:7a:

James 3:13:

Matthew 5:15-16:

Do you agree that faith or belief and works go hand-in-hand? Are you ready to put your faith into action? I believe that at the center of following Him is the need to die to ourselves. We must let go of our rights, our wants, and our desires – even our fears and surrender our will to the will of God.

If you believe that God has the power to transform lives, then live in a manner that allows others to see His power working in you! When you see someone in need, help them in a tangible way – provide a meal, spend time encouraging them, watch their children for a while to give them a needed respite. Is your church looking for volunteers? Sign up to help out in the nursery, bring donuts, or make coffee, or sign up to help decorate for the next women's event. Use your time, talent, and resources for the glory of God and for His kingdom!

"Good works are not our gifts to God but rather His gifts to us! Our heavenly Father has a plan to do some wonderful things in this world and, because of His great love for us, He has chosen to allow us to participate in that work. We have already seen that He doesn't need us to do the work. He chooses to do the work through us because He loves us."[2]

—Steve McVey

Day Five
Examining Our Hearts

Rahab believed that God was to be acknowledged high above all other people and things. She declared that He was "Yahweh" and believed that He was powerful, knowing He could and would destroy her city and all those within its walls. She believed God had the power to save her and to transform her and her belief was put into action when she defied the governmental officers and lied to keep the spies safe at significant risk to herself and her family. Because of all she believed, she stepped out in faith to protect God's servants.

So, what do you believe?

Do you struggle with a sinful past and choices you regret?
Record the truth you find in 2 Corinthians 5:17.

Record the truth you find in Romans 8:1-2.

Do you struggle with feeling loved by God?
Record the truth you find in 1 John 4:10.

Record the truth you find in Ephesians 2:4-8.

Do you struggle with believing you have a purpose in life?
Record the truth you find in Jeremiah 29:11.

Record the truth you find in Philippians 1:6.

How would we live differently if we genuinely believed that God is all He says He is in His Word, AND we stepped out and put that belief into action, every minute of every day? I'm not trying to heap a bunch of conviction upon anyone, but I want for us to really think about what we believe and if it really influences how we act and the choices we make. I read somewhere that "what you believe and whom you serve will determine your choices and how you work out and act upon your faith – which will determine how you behave."

Personally, I struggle with past mistakes. I don't have a background like Rahab, but there are actions and events in my past I would love the opportunity to do over. I am so encouraged by Rahab! This woman, who most people would consider a "hot mess" – a prostitute and an idol worshipper. BUT, our holy God recorded her by name in His Word and added her to the lineage of His only cherished Son, Jesus. Because of her strength in standing in her faith and belief in the power of God, she is listed among the elite saints in Hebrews. God can transform a life!

In *Life Principles from the Women of the Bible* it says "Perhaps you have been plagued with guilt from past sins and have believed the lie that God could never use you because of your sinful past. You cannot alter the past, but you can put your past on the altar. If you surrender your past failures to God, you may be surprised to discover that instead of a hindrance to Him using you, they may become the very thing that makes you usable."[3] Rahab is a beautiful example of the power of transforming faith; she is a reminder that even the worst of sinners can be redeemed by God's grace received through faith.

The story of Rahab is one of remarkable transformation. She had heard the stories about Jehovah God and believed God was powerful and faithful to do all He promised to do. Her belief in the God over all heaven and earth fueled her choices to hide the spies, lie to the officials, and ask the spies to save her and her family. And when the walls of Jericho came tumbling down, Rahab was spared and welcomed into the family of God.

Cultivating
a Heart that Believes

So, what steps can we follow to cultivate a heart willing to believe the promises of God and the truth of His Word?

1 Remain teachable. Keep your ears tuned to listening to God's teaching and direction and keep your heart open to be changed and molded as He sees fit.

Record 2 Peter 3:18a below, inserting your name:

2 Connect what you believe to how you respond to truths God has made known to us. Is there something we believe that we are not acting on? Are you being obedient to all that He has asked you to do? Your walk with God and your ministry to others are directly tied to what you do with what God has revealed to you.

Record 1 John 5:2 below, inserting your name:

3 Refuse to believe any lies associated with your old self. Remember, God has made you new. You are not a failure, a mess, unworthy, shamed, unloved, or unacceptable. God loves you fully and completely. You are His child, and you are wonderfully made!

Record Ephesians 4:22-24 below, inserting your name:

4 Know the word of God. Spend time reading your Bible and become well acquainted with His Truths.

Record Colossians 3:16 below, inserting your name:

Additional Notes:

HOW TO KNOW JESUS

Sweet friend, there is no greater joy than being at peace with God and knowing that you will live in eternity with Him. Being a good person, going to church, or giving money to charities, for example, are all good things and come from a good heart. The problem is that by God's standard, good people don't go to heaven when they die. Only holy people go to heaven.

While that may sound impossible, it isn't. Every one of us has sin in our lives—things we have done that are displeasing to and disobedient to God. Whether we told a little white lie, committed a heinous crime, or did anything in between, it is all sin. And in God's eyes, the debt of sin must be paid.

And the payment for and the penalty for sin is death.

Jesus Christ was God's Son, born of a virgin. He lived a perfect and sinless life on earth for 33 years until He was crucified. Because He was a sinless, spotless sacrifice, His death paid the penalty for sin.

The question is, will you accept the death of Jesus in your place to pay the debt you owe God for your sin, or do you want to pay the debt on your own? One day, we will stand before God, and He will ask about our payment method. If you have accepted the gift of Jesus as your payment, you will enter into eternity with God. If you decided to reject Jesus and make the payment on your own by trying to be good enough to get in, God will require you to make the payment of your spiritual death for your sin—eternal separation from God in a place of torment. If you have waited until after you are face-to-face with God to call on the name of Jesus, you will be too late.

So how do you accept Jesus' death as payment for your sin now?

Simply pray the prayer below. *Prayer is simply talking with God silently or out loud.*

DEAR GOD, I ADMIT THAT I HAVE SIN IN MY LIFE AND HAVE DONE THINGS THAT ARE DISPLEASING AND DISOBEDIENT TO YOU AND YOUR WORD. PLEASE FORGIVE ME OF MY SIN. I ACCEPT THE PAYMENT THAT YOUR SON, JESUS, MADE ON THE CROSS IN MY PLACE. I ACCEPT YOUR SON AS MY SAVIOR, SAVING ME FROM BEING ETERNALLY SEPARATED FROM YOU. JESUS, PLEASE COME INTO MY HEART. AMEN.

Is it really that simple? Is it really just praying that simple prayer? Yes, it is! If you are truly sorry for your actions against God and accept the payment of Jesus to cover them, then through God's forgiveness and grace you are saved.

If you prayed this prayer, I encourage you to tell someone—a Christian friend, a pastor, a church leader, or someone else—and get connected with your local church so you can grow in your newfound salvation.

LESSON TWO

Hannah
a heart that prays

A HEART AFTER GOD

I was taught how to pray at an early age. My momma taught me to fold my little hands and recite, "God is great; God is good; let us thank Him for our food." I certainly didn't understand the importance of prayer, but I got a good idea of its necessity if I wanted to eat! I have also been told that prayer is simply talking with God, and while that is true, I have come to learn it is really my lifeline to my heavenly Father. Prayer has become as important to me as the air I breathe.

Whether prayer comes easily to you, or you are scared someone might call on you to close your Bible study gathering in prayer aloud, know that you get better at prayer with practice. It is a spiritual discipline that isn't always natural and can feel a little awkward. Way too often, we are seeming to walk through life with ease, and then suddenly a crisis arises, and we realize our desperate need for God, crying out to Him in desperation to help us. And, when God rescues us, we promise to spend more time in His Word and in prayer, knowing how much we really need Him, only to revert to old patterns and forgetting to talk with God every day along the way. We need to learn to have a moment-by-moment prayer life, where we tell Him everything about our day. Prayer should be our first response, not our last resort!

Prayer should be as natural and necessary to us as breathing. Scripture tells us we need to pray about everything – about our worries and our cares, about our joys, about our successes, about our fears – about everything! And Hannah is a beautiful example to us of a woman who took her fears, concerns, desires, hurts, and frustrations to God. She is an example of a heart that prays.

Day One
Introduction & History

Hannah's story is from the book of 1 Samuel. This book was written during the time where Israel was led by Judges. God called a total of 12 judges for two purposes. First, they were chosen to be military leaders to rescue Israel from her enemies. In addition, they worked to reestablish the religious practices of the Torah when Israel strayed from God. Over time, the people of Israel did not want this type of governance and begged God to give them a King. The book of 1 Samuel tells the story of how God established a monarchy in Israel.

In addition to judges, Israel also had spiritual leaders called priests. The priests were men from the tribe of Levi, in the lineage of Moses and Aaron. These men were given the responsibility of taking care of the most sacred things of the tabernacle, including the Ark of the Covenant.

The tribe of Levi was chosen by God to be dedicated to His service. You may recall the story of Moses, when he went on the mountain to receive the law from God, written by God's own finger on two stone tablets. While he was on the mountain, the people grew impatient and became rebellious, then created for themselves a golden calf, an idol they began to worship. When Moses came down from the mountain, he was enraged and threw the tablets on the ground, breaking them into pieces.

Skim Exodus 32, then concentrate on Exodus 32:25-29.
Why did God choose the Levites for service unto Him?

First Chronicles 6:1-3 lists the descendants of Levi.
Looking at verse 3a, what names do you see?

What do you learn about the Levites from Numbers 8:10-12?

Read Numbers 18:1-7 and record the duties of the Levites you see listed:

The High Priest at this time was Eli, and he was considered a good leader; however, his sons were behaving wickedly and against God's commands. While Eli addressed their behavior, he did not stop their wickedness, and so the priesthood of this era was considered corrupt. It is during this historical time that the story of Hannah is set, and her son Samuel is born. As we will see, Hannah trusted the care and training of Samuel to Eli, who trained the boy to be in the service of God. Eventually, Samuel grew to be the last judge of Israel, a priest by Hebrew lineage and the one who anointed both King Saul and King David.

How does 1 Samuel 2:12 describe Eli's sons?

Was it customary for sons to follow their fathers as priests?
Read I Chronicles 6:49 for your answer.

The Tribe of Levi was responsible for taking care of the most sacred things of the tabernacle, including the Ark of the Covenant. By God's law, the Levites were not given any land when the Israelites entered the Promised Land, and so the tribe was scattered throughout the other territories of Israel. Throughout the year, the men of Levi took turns serving in the tabernacle. Our story today begins with Elkanah and his family taking a pilgrimage for Elkanah to serve in the temple, where Eli was the high priest.

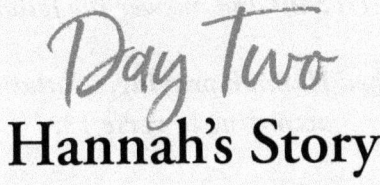

Hannah's Story

The name Hannah means gracious or favor. This gracious woman lived in a remote part of Israel, in the territory of Ephraim, with her husband, Elkanah. As we see in scripture, Hannah faithfully went with Elkanah on the journey to the tabernacle when it was his assigned time to serve.

While this may sound like a nice, simple life, Hannah's life was difficult, and she was tormented. First, Hannah was not Elkanah's only wife. While polygamy was discouraged, it was not forbidden by God during this time in history, and Elkanah had also married a woman named Peninnah. This situation created a huge rivalry between the two women.

Read 1 Samuel 1:1-7 and record what you learn about Hannah's family situation.

What did Hannah do in her anguish in I Samuel 1:10-11?
Record any words of interest to you or promises she made.

Read Numbers 6:1-8 and record all you learn, including the special name given to the vow described in this passage.

Hannah | a heart that prays

Read 1 Samuel 1:12-20 and answer the following questions:

As the priest, Eli watched Hannah praying, what did he believe about her according to verse 13?

What was Hannah's explanation to him in verse 15?

What was Eli's response in verse 17?

How was Hannah's countenance changed once she had poured out her heart before God according to verse 18?

According to verse 20, did God answer Hannah's prayer?

While scripture does not record how long it was before God answered her prayer, Hannah eventually gave birth to a son named Samuel. And, when he was a small boy, she brought him to the High Priest, Eli, to be trained in God's service. Samuel grew up to be the last judge of Israel. He was also a priest by Hebrew lineage and was called by God to anoint Saul (the first King of Israel) and then David to be king. The name Samuel means heard of God, and what a beautiful reminder that God hears us and answer our prayers.

Read both Proverbs 16:9 and Proverbs 19:21 and record what you learn about the plans we have for our lives.

When we bring God our requests, sometimes He grants us our petition, sometimes He denies our requests, and other times, we simply must wait to see His answer.

Unlike Hannah, despite our most fervent prayers, sometimes God's answer is no. Record the comfort and encouragement you find in Psalms 62:5-8.

Have you ever been in a situation where God didn't immediately give you something you wanted? How did God ultimately resolve the situation for good?

Write Psalm 27:13-14 below, inserting your name into the verse.

Day Three
Hannah's Character

When we look a little deeper into Hannah's actions, there are several things we can apply to our own lives. First, Hannah was faithful and kept her promise. Remember, as she was praying, she vowed to give her baby back to the Lord for His service if God would bless her with a child. While she had several years with her precious Samuel, the day came when she returned to the temple and presented her son to Eli the priest.

Record what Hannah said to Eli in I Samuel 1:26-28.

Read Hannah's beautiful prayer in 1 Samuel 2:1-10 and record phrases that speak of praise for God's goodness and mighty deeds.

Hannah intimately knew God and had a deep relationship with Him. This period in history was not one of spiritual depth in the religious leaders, who were in fact terrible examples for the Jewish people and faith. Yet, Hannah's faith was strong. Believing God was fully able to grant her desire and longing for a child, she committed to give her child back to God before she had even conceived. What amazing faith she had and a great desire for her son to turn the nation back to God.

In addition to being faithful, Hannah exercised great control and watched over her words. She knew when to speak and when to remain silent. She endured mocking and ridicule from the other wife of Elkanah. In addition, her religious leader mistook her fervent prayers for drunken rambling! But never does scripture record that Hannah stooped to the level of assaulting back in a war of words; instead, Hannah poured out her heart to God in prayer.

What sound advice do you read in James 1:19-20?

What encouragement do you find in Psalm 55:16-18, 22?

We also see in Hannah a deep and abiding love for God, as evidenced by her passionate and deep prayer life. The Hebrew word for pray used in these scriptures is "palal." This Hebrew verb speaks of a type of prayer that always involves a personal relationship. It is an intensely personal act, with the focus on the individual, not on the congregation. This form of prayer is begging the favor of the Lord about the issues that deeply concern the worshipper.

How do you see this attitude reflected in the Psalmist's words in Psalm 63:1-4?

What encouragement do you find in James 4:8?

Finally, we see that Hannah never complained, despite her great sorrow. There is no indication that she grumbled against God or turned her back on her faith. Amid great pain, frustration, and disappointment, coupled with the torment she experienced from Elkanah's other wife, Peninnah, Hannah remained continually faithful to God and persisted in prayer.

What do you learn from the following verses?

Romans 12:12:

Philippians 2:14-15:

1 Peter 4:8-10:

Hannah brought all her sorrow, disappointment, frustration, and pain to the Lord, and left it there. She poured out her heart to God — it was heartfelt, tearful, and physical. Although Psalm 62:8 tells us to pour out our hearts to God, sometimes we are reluctant to do so. We fear that we might offend Him or expose something about ourselves that we

don't want Him to know. Guess what? He already does! He knows everything about you —everything you have done or ever will do, all your thoughts, all your emotions, AND He loves you anyway!

YOU are His precious child, and you are safe to pour out your whole heart before Him. After all, He has the power to heal your broken heart and to answer your prayers. "The heart of God is a comforting retreat for a sorrowful soul."[4] He longs for you to pour out everything to Him in prayer so He can comfort you, show you His tender compassion, and heal your ravaged soul. He understands our feelings and invites us to bring our requests before Him. Know that He is trustworthy to carry your burden, and He is faithful to answer your prayer.

Day Four
A Deeper Understanding of Prayer

We see that Hannah's life was characterized by prayer, but what is prayer? People often look at prayer like an ATM — we put our requests in and then expect God to give us an answer immediately! Then, if His answers are different than what we wanted, or He is slow in His response, we become angry. Or worse, we lose faith and doubt God's love for us.

We need to understand that God's answers to our prayers are about what brings HIM glory. Psalm 19:1 tells us that the heavens declare the glory of God and that God is the center point of our universe, our world, and our very existence. Everything revolves around HIM. God is central in everything, and His glory is central to our prayers.

Look up the definition of the word "prayer" and record it below:

In the book, *The Kneeling Christian*, it says, "The chief object of prayer is to glorify the Lord Jesus. We are to ask in Christ's name 'that the Father may be glorified in the Son' (John 24:13). Listen! We are not to seek wealth or health, prosperity of success, ease or comfort,

spirituality, or fruitfulness in service simply for our own enjoyment or advancement or popularity, but only for Christ's sake – for His glory."[5] We must learn, as hard as it is sometimes, that God's answer to our prayer may be "no," no matter how much we may desire a different answer. We often struggle to accept that God did not choose to say "yes" to what we wanted. Know this: He is God. He is on the throne. He will be glorified. And, even when His answer is "no," His love for you has not changed. In fact, because He loves you, He only wants the absolute best for you.

Read Isaiah 55:8-9 and record it below:

My mother was a Christian counselor, speaker, and woman totally sold out to serving God, and she had ovarian cancer. We prayed fervently that she would be healed and believed beyond any doubt that God was able to heal her. After battling cancer for two years, God took her home — obviously, not the answer to prayer I wanted. I wanted her healed on earth, because after all, that seemed to me to demonstrate God's power in an amazing way. But God chose to heal her in Heaven. I have often said that I believe that my mom was so special to Him, so loved by Him, that He chose to heal her face-to-face rather than at a distance. I don't understand why He didn't heal her here on Earth, and most likely I never will until I am also face-to-face with Jesus. Until then, I claim the truth in Isaiah 55:8-9, which tells me God's ways are higher and better than mine. I choose to trust Him.

Now, read Matthew 7:7-10 and record what you learn below:

God desires to give us good things. And while we would like those good answers to every prayer, just like a good parent, He isn't going to give us ice cream, cookies, and puppies every time we ask Him for something. Sometimes the best for us is to eat vegetables, to get shots when we need them, and maybe even to withhold something that He knows isn't in our best interest!

Read the following verses about prayer and record any phrases that are meaningful to you or anything that you learn from them.

Psalm 141:1-2:

Psalm 27:7-8:

1 Thessalonians 5:17-18:

Luke 18:1-8:

What is your attitude toward prayer? Are you one who runs to God, taking every care and concern to Him or are you more reserved? I think sometimes we are maybe a bit afraid of truly pouring out our hearts before Him. After all, He must be busy with so many other "big" things like wars, famines, and earthquakes…does He really care that I need some extra courage or extra patience today as I face an unsettling circumstance?

Read Hebrews 4:14-16 and record how Jesus responds to our prayers and the attitude we should approach God with our concerns.

Oh friend! Don't be afraid to bring all your cares before Him! He loves you, and He wants you to bring Him your burdens.

Day Five
Examining Our Hearts

Prayer is a call to intimacy with the great God of the universe. God, Who created everything, Who owns everything, Who gives us every breath and every heartbeat – wants to be in an intimate relationship with you! He is waiting to commune with you; He is ready to listen to you, available anytime; He wants us to involve Him in every area of our life; and He knows that we need help.

For the next few minutes, pour over Romans 8:26-28.
Take time to examine the verses, looking over each word and each phrase.
Write the things you see that bring you encouragement or understanding.

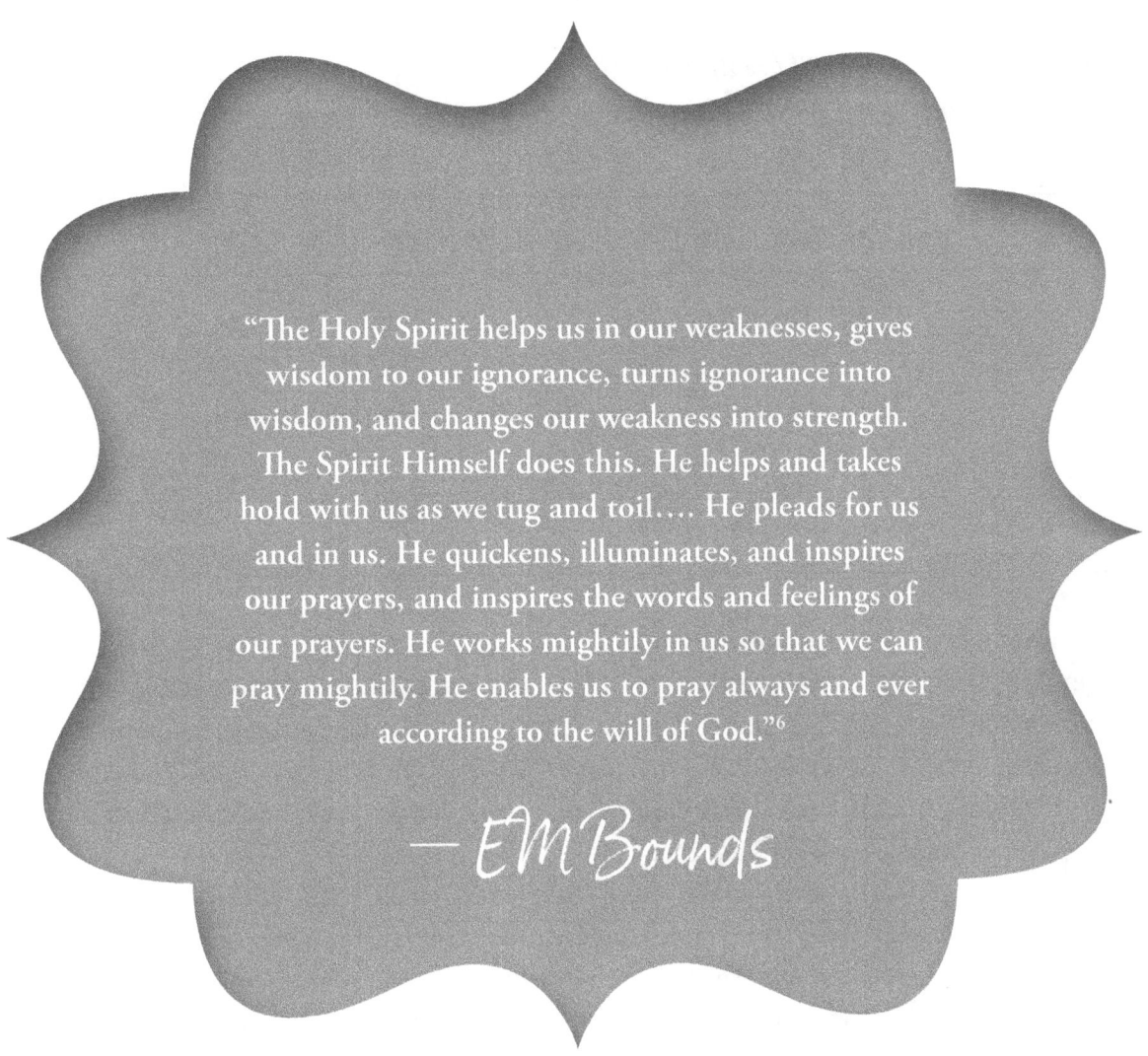

God also gives us His word that we can use when praying, which help us better focus on eternal things rather than earthly things.

What does Colossians 4:2 tell us to do concerning prayer?

Some Bible translations will use the word "devote" instead of "continue" in the above verse. Look up the word devote in a dictionary and record the definition below.

How often should we pray according to Romans 12:12?

God wants us to come into His presence and rest and remain patient as we wait for His answer. God loves to answer our prayers, just as a parent loves to give good things to their children; however, He doesn't always give us an immediate response. Sometimes He wants to develop our character or increase our faith before He can answer. Know that God's delays are not always God's denials. Yet, it is so hard to rest and not get impatient when God seems to be taking His time.

Soon after I moved to Houston, David and I were dating and not engaged, and he came up with a great idea for a date. We went to a lovely park west of Houston, where we had a picnic, played Frisbee, and had a very fun day — a perfect day. But I was grumpy! After all, here was this perfect day, this perfect guy, and a perfectly empty fourth finger on my left hand! Finally, David asked what he could do to make me happy, and I blurted out, "You can go to the car, pull out a ring, and ask me to marry you!"

David laughed, rolled up the picnic blanket, packed the car, and drove me back home. Little did I know that that is exactly what he was planning to do. My ring was sitting in the glove box. His plan was to propose, but my impatience ruined the whole thing!

How many times have we gotten impatient with our heavenly Groom? We don't understand why He isn't answering our prayers the way we want. Why He has left us in our suffering. Why He has remained seemingly silent. Warren Wiersbe said, "Here is a secret for endurance when the going is tough: God is producing a harvest in our lives. He wants the fruit of the Spirit to grow (Gal. 5:22-23), and the only way He can do it is through trials and troubles. Instead of growing impatient with God and with ourselves, we must yield to the Lord and permit the fruit grow."[7]

Record Psalm 37:4 below, inserting your name:

I think we often read this verse, and we believe that God is going to give us whatever our heart desires. Oh, I don't think this verse is about us getting what we want! I believe it is about God giving us the desires; it is about Him creating the desires and putting them into our hearts. Then our hearts will desire what He desires.

Cultivating a Heart that Prays

Oh, sweet friend! I wish that everything in life was easy; but unfortunately, hurt is going to come and life is going to have challenges. During these tough times, we can't forget to constantly turn to God in prayer and leave our frustrations and hurts at His feet. We need to learn to be patient when things aren't going our way. God is still on the throne; He is still in charge; He still loves you deeply and sees your pain. He knows what is best for you and is working for your good. Be patient until His timing is made perfect.

In our own lives, we need to make sure that the words that pass between our lips build up and bless other people. We must learn to respond to others with grace, or not respond at all. Several years ago, I found myself in a war of words in a situation that involved a loved one accused of something by friends. My husband wisely instructed me to remain silent. What great advice he had because my words would have been angry and defensive; and honestly, I believe I would have given the group of accusers the ammunition to use against me. Instead, the intensity of the situation died down because I didn't fan the flames. As the saying goes, "hurt people, hurt people." I was so hurt by this situation that I know my words would have been hurtful if I had allowed myself to speak. Once words have come out of our mouths, we can't get them back. We must learn to respond in grace, or not at all.

Here's the bottom line. Jesus is trustworthy; you can trust Him with your heart, your desires, your joys, and your pain. Jesus is strong; He can carry the weight of your burden. Jesus is enough; He is truly all that you need and will satisfy every longing in your heart. We must keep our eyes fixed on Him alone. "What did Hannah personally learn about God from her suffering? What did she learn about Him? She learned to depend on Him. What did she learn about His relationship to her? He listened to her; He answered her prayer. What did this prove about Him? That He loved her! That He loved her and that He was interested in every detail of her life. That He accepted her! She experienced His power and His fruitfulness, and she learned that her truest joy was in God alone." (Author unknown)

Only God can fill our heart with permanent joy, and Hannah found that joy.

Additional Notes:

LESSON THREE

Ruth
a heart that loves

A HEART AFTER GOD

When I was four, I got my first pair of ballet shoes – pink, soft leather, with white string ties and suede soles —and a performer was born! I loved being on stage. Unfortunately, performance became a habit, and rather than just experiencing the spotlight for a moment, I carried the idea of performing into my daily life. I found myself performing to gain love and approval from others, which then led to performing in attempts to get God to love me more.

When I Peter 2:9 says we are chosen, my first thought is, What have I done to deserve that honor? The answer: NOTHING! All our working, striving, and performing to gain God's approval is pointless! It is all about HIS action – HE chose us simply and marvelously because He loves us. Unexplainable, undeniable, undeserved, overwhelming, deep, and perfect love from above, that we do nothing to earn or keep. We simply receive His free gift of lavish love.

You and I are loved and accepted completely by God and not because of anything we have done to earn His love. He can't love you anymore than He does now. You can't earn His approval by doing things. God has chosen you, and He sees you as holy! We don't need to perform for His blessing; we already have it.

This week, we are going to look at love through Ruth's commitment to her mother-in-law, Naomi, and her commitment to Jehovah God. We will also see God's unconditional love and protection for two precious widows. Ruth is a beautiful example for us of a heart that loves and a precious woman who is loved deeply by God.

Day One
Introduction & History

Ruth's story begins before we are introduced to our main character, as a Jewish family decides to leave Israel and go to Moab in search of food during a famine.

If you have studied the Old Testament before, you probably know that the names of individuals are very important. Every name has a meaning, which usually describes the person or gives prophetic announcement or warning. And this Old Testament story in Ruth is full of descriptive names that enhance this narrative.

As the book of Ruth begins, we are introduced to a family. Below is a chart of their names, the meaning of the name, and who they are in this story:

Elimelech	*"My God is King"*	Husband and Father
Naomi	*"Pleasant"*	Wife and Mother
Chilion	*"Puny"*	Son and future husband of Orpah
Mahlon	*"Unhealthy"*	Son and future husband of Ruth

And they live in a town called Bethlehem, which means "House of Bread."

As the story begins, famine strikes in Israel, and this man, whose name declares God is everything to him, becomes fearful (although he lives in the "house of bread") and flees to Moab. Just on the surface, this seems all wrong to me. While scripture doesn't really say, it appears that they may be the only family who leaves Bethlehem in fear of the famine. As we will see later in the book, Naomi will return, and her friends are still living in Bethlehem and seem to be fine. Maybe because their children were "puny" and "unhealthy," they felt an added responsibility to care for them and were worried about supplying food for their "health-challenged" sons, but we are not told in scripture.

I know I'm reading a bit into this passage and making a few assumptions about the mindset of Elimelech and Naomi that is based more on my personal knowledge of human nature rather than what we learn from scripture. But it seems to me that this family could have made this decision to move from "House of Bread" (Bethlehem) out of fear rather that trusting that God would provide for them. I could be totally wrong, but there is a truth I want to speak over us all – fear should never be our motivation for making big decisions. Most of the time (if not every time) our decision will be purely emotional, and most of the time it will be out of God's will. If fear is the driving force of a decision you are making, please stop and breathe! Our decisions need to be from faith in God, waiting for Him to act on our behalf and show us clearly what path He wants us to take.

How do the following verses encourage you not to fear?

Joshua 1:9:

Psalm 34:4:

Psalm 46:1-3:

2 Timothy 1:7:

So, our family of four has chosen to move to Moab – an evil city with a wretched past. Moab and its inhabitants were hostile towards Israel and an enemy of the people of God. Moving to this land seems to be a questionable choice for a devout Jew to make a home for his family.

To begin looking at Moab, we will go back to the book of Genesis and the stories of Abraham and his nephew, Lot.

Read Genesis 13:1-17 and summarize below what you learn:

We don't really hear much about Lot until Genesis 19, when we see the wickedness of Sodom and Gomorrah and God's intent to destroy both cities and all the inhabitants. In His mercy, God gives a warning to Lot and his family to leave Sodom prior to its destruction.

Read this account in Genesis 19:1-29 and record any interesting details of this story below:

Following the destruction of Sodom and Gomorrah, Lot and his daughters move to a new land. Here, a very disturbing story is recorded and the dark beginning of the people of Moab ensues.

Record what you learn from Genesis 19:30-38.

Wow. Such an ugly story and doesn't seem like it should have a place in the Holy Word of God. While I completely condemn and abhor what happened in this story, I do appreciate that God has included it in scripture. People are sinful, and it is in our nature to be sinful. But God! God has the power, the love, the grace to forgive all sin, even the most heinous.

Read Ephesians 1:7-8 and record the glorious promises you find below:

*There are some other places where Moab is mentioned in scripture.
What do you learn from the following verses?*

Psalm 60:8a:

Zephaniah 2:8-11:

In our Day Two questions, we will read about the practice of gleaning. Since we are reviewing history today, and in preparation to better understand our story, I think it would be helpful to look at this practice in advance. For those in abject poverty, God set laws about the practice of gleaning, or gathering "leftovers" during the harvesting of land.

What do you learn of gleaning from the following:

Leviticus 19:9-10:

Deuteronomy 24:19-21:

Don't you love seeing the tender heart of God for those in need?

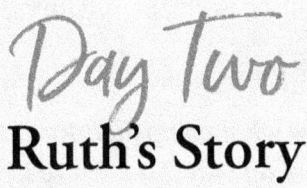

Day Two
Ruth's Story

As we continue studying this family, Naomi's husband, Elimelech dies, leaving Naomi to raise her sons alone. As they grew into adulthood, they both chose to marry Moabite women. This was a questionable choice for a devout Jewish man as God had forbidden them to marry foreign women.

According to Deuteronomy 7:1-4, why did God forbid intermarrying?

So, Naomi is in a terrible place, in a pagan country, with no husband, and her sons in marriages which God has forbidden for his children; and disaster strikes; her sons both die within about 10 years of their marriages, leaving their wives, Orpah and Ruth, widowed. I cannot imagine Naomi's pain.

All is lost to Naomi and in her despair, she decides to return to Bethlehem, and her daughters-in-law commit to go with her. Orpah only makes part of the journey with Naomi, and then decides to return home to her family and back to a life of idolatry; however, Ruth decides to give her former life up and continue with Naomi. (We will look at Ruth's beautiful response to Naomi tomorrow.)

Read Ruth 1:6-14 and record what you learn from Naomi's interaction with her daughters-in-law below:

I think Ruth was so brave to continue to Bethlehem with Naomi, leaving behind her family, her county, her religion, and her home.

While we do not know what compelled Ruth to make this decision, what factors do you think led to her decision?

In the "Day One" questions of this lesson, we looked at the practice of gleaning, a means by which God had provided for the widows and orphans to be able to eat by picking up the harvest left behind by the reapers in fields. In Chapter 2 of Ruth, we see Naomi sending Ruth to gather food through gleaning, and Ruth happening to work in an area of land belonging to a man named Boaz.

What do you learn about Boaz from Ruth 2:1?

Boaz also takes notice of Ruth as she is working in the fields. Skim Ruth 2:8-16 and record anything you learn or notice from this passage, especially noting the tenderness of Boaz toward Ruth.

When Ruth returns home, Naomi is overjoyed and explains to Ruth that Boaz is a member of their family and can be a Kinsmen-Redeemer for Ruth and their family. A Kinsmen-Redeemer is a provision in scripture to protect the needy. The word "Kinsman-Redeemer" literally means "to set free by paying a price." This family redeemer had both the privilege and responsibility to step in when another family member was in trouble or danger. In Naomi and Ruth's situation during this period of history, inheritance and property passed to the nearest male heir upon the death of the patriarch, and without a husband or son, both Naomi and

Ruth were faced with a future of poverty. Through the laws of the provision of a Kinsmen-Redeemer, if Boaz and Ruth marry, their first-born son would be considered a son of Mahlon and the inheritance and land of Elimelech would be secured.

In the third chapter of Ruth, the moment when Ruth asks Boaz to be her redeemer is recorded. Through her words, she literally asks him to cover her with his "wings" in Ruth 3:9. This is such a beautiful picture of protection, comfort, and love.

Read Psalm 91:1-4 in the New International Version (printed below).
What comfort and encouragement do you find in these verses?

1 Whoever dwells in the shelter of the Most High
will rest in the shadow of the Almighty.
2 I will say of the Lord, "He is my refuge and my fortress,
my God, in whom I trust."
3 Surely he will save you from the fowler's snare
and from the deadly pestilence.
4 He will cover you with his feathers, and under his wings you will find refuge;
his faithfulness will be your shield and rampart.

The book of Ruth ends with the marriage of Ruth and Boaz and the birth of her son Obed, who was the father of Jesse, and the grandfather of King David. This means that Ruth, the widowed Moabite woman, was King David's great-grandmother and part of the lineage of Jesus Christ!

Don't you love this story? Think about Ruth: a pagan widow with no hope and no possibility for a future outside of abject poverty. A woman whom the society of the day would have rejected and cast aside, for no reason. A woman who worshipped gods other than Jehovah — and yet, God saw her. He provided for her. He sent a redeemer to her to restore her dignity and her family. God offered her a relationship with Him – the One True God. God saw past all the flaws, mistakes, and stereotypes to Ruth's heart – a heart that loved and honored her mother-in-law and one that sought after Him. He responded with love, grace, and comfort.

As we conclude today, write a prayer of gratitude below for the ways that God has provided for you in your times of need. Times when you felt as if no one could see you, but God did. Times when you didn't do anything to earn God's favor, but He sent it to you in abundance. Times when He offered you comfort and peace in the midst of a storm. Times when He met your need, but physical and emotional. Oh friend, God is always there – just as Boaz was Ruth's Kinsmen-Redeemer, Jesus has redeemed you as well.

Write your prayer of gratitude in the space provided below:

Day Three
Ruth's Character

Today, we will look deeper into the character traits that we can see in Ruth's life and that we can work to cultivate in our own lives.

First, I see that Ruth was steadfast and loyal and she wasn't afraid of making a commitment. We see that in her choice to stay with Naomi. Ruth was not under any law that required her to stay with Naomi, and because she was young and her husband had died, she could have easily remained in Moab and started again, most likely to remarry and possibly have children, but she chose to remain with Naomi, leaving the familiar behind to head to the unknown.

***Read Ruth 1:16-17 and record anything you see that expresses Ruth's commitment both to Naomi and to Naomi's God – Jehovah.
How seriously does it seem that Ruth took her commitment?***

This is an amazing declaration from Ruth. In Hebrew, the word translated "go" in this verse means that Ruth is willing to follow Naomi, without knowing any definite direction of where she is heading. It is like she says, "I don't know where you are going, Naomi, but I'm sticking with you!" I also love how Ruth addresses God in these verses. While I don't know any Hebrew, I am aware that in scripture, there are many different Hebrew names for God, all pointing to a different aspect or attribute of God. When Ruth says that Naomi's God will be hers, she uses a name of God (Elohim) that speaks to God being the ruler or judge; however, in verse 17, she refers to God as "Yahweh," which is the covenant name of God, emphasizing His relationship with the Jewish nation.

Why do you think Ruth was willing to make such a commitment?

What influence do you think Naomi had on her decision?

I believe Ruth was able to make this decision and declaration because of her capacity to love. Ruth could have been bitter. After all, her husband, brother-in-law, and father-in-law have all passed away suddenly, and she is a young woman in a very difficult situation.

What do you learn about loving others from the following verses?

John 13:35:

Romans 12:10:

I Peter 4:8:

1 John 4:11-12:

And because of Ruth's great capacity to love, it leads to the second character trait I see in her — that she was servant-hearted. She tenderly took care of her mother-in-law, gathering food for them to eat, and then following her instructions on basically proposing to Boaz without question or complaint.

Look up the word "servant" in the dictionary and record the definition below.
(Use a Bible Dictionary if possible.):

What do you learn about being a servant from the following verses?

Matthew 20:26-28:

Galatians 5:13:

Read 2 Corinthians 4:6-7 and write this amazing verse below:

Have you ever really thought about a clay pot? I have seen some that are decorative, and some that are plain terracotta, but they are all fragile. I'm not sure that anyone would carry something of great value in a clay pot; but we are compared to jars of clay! And even more amazing, it is within the fragile clay pot of our being, that God has chosen to place the very Spirit of our Holy God – a treasure of greatest worth!

How often do we focus on the cracks and imperfections that we have? We feel inadequate and flawed at times, but really, those cracks are the avenues that allow God to shine through us; in fact, the more cracks we have, the more of God others see!

What opportunities do you see currently where you can serve another person in love? What will be the first action step you will take toward serving them?

Write a prayer to God below, asking Him for the strength to serve others and thanking Him for His ability to shine through your imperfections.

Day Four
A Deeper Understanding of Love

According to Ephesians 3:19-20, Paul prays that the saints "may have strength to comprehend with all the saints what is the breadth and length and height and depth, and to know the love of Christ that surpasses knowledge, that you may be filled with all the fullness of God." What a prayer! That we would have the strength to comprehend the love of Christ that is beyond knowledge. See, the love of God is just too deep, broad, high, and vast for us to fully grasp! That is the immense love that God has for you!

According to John 13:34-35, why is it important that we work to understand love?

One of the most well-known passages in scripture about love is found in I Corinthians 13:4-7.

Read 1 Corinthians 13:4-7

Take your time in really thinking on these verses. Don't just read the words and phrases, but go through each verse slowly, and reflect with the following sentences by saying: "God's love for me is _____." Then complete the sentence with the words from the passage for example, "God's love for me is patient." Then, reverse the sentence as "My love for others should be _____."

As you reflected on these verses using the fill-in-the-blank prompts, what thoughts encouraged you? What words challenged you?

Write down any words that describe love from I Corinthians 13:4-7 that you find challenging or encouraging. To gain a deeper understanding of these words, use a dictionary to look up the meaning of them.

According to John 15:13, what is the greatest thing a man can do for another?

According to Romans 5:8, what did Jesus do for you?

What is God's promise concerning this gift according to John 3:16?

According to Galatians 5:22, where do we receive the ability to love?

Day Five
Examining Our Hearts

John MacArthur said, "Every kinsman-redeemer was, in effect, a living illustration of the position and work of Christ with respect to His people; He is our true Kinsman-Redeemer, who becomes our human Brother, buys us back from our bondage to evil, redeems our lives from death, and ultimately returns to us everything we lost because of our sin."[8]

Don't you love that the word redeem means to set free? That is exactly what Boaz did for Ruth:

- He set her free from the life of mourning she had been living.
- He set her free from a life of poverty.
- He set her free from the law, which said she could not be a part of God's people, as a foreigner and a pagan.

This is also what Jesus Christ has done for you and me. He has set us free! One of my favorite passages about Jesus is found in the Old Testament and is a prophecy about our Savior, but it speaks so beautifully and poetically about the work of Jesus. Below is the passage from Isaiah 61 from The Message. (As you read, remember that the "me" in the passage is prophetically referring to Jesus.)

> *The Spirit of God, the Master, is on me because God anointed me. He sent me to preach good news to the poor, heal the heartbroken, announce freedom to all captives, pardon all prisoners. God sent me to announce the year of his grace—a celebration of God's destruction of our enemies—and to comfort all who mourn, to care for the needs of all who mourn in Zion, give them bouquets of roses instead of ashes, messages of joy instead of news of doom, a praising heart instead of a languid spirit. Rename them "Oaks of Righteousness."*
>
> *I will sing for joy in God, explode in praise from deep in my soul! He dressed me up in a suit of salvation, he outfitted me in a robe of righteousness, as a bridegroom who puts on a tuxedo and a bride a jeweled tiara. For as the earth bursts with spring wildflowers, and as a garden cascades with blossoms, So the Master, God, brings righteousness into full bloom and puts praise on display before the nations.*

Look up the definition of "redeemed" in a dictionary. (If possible, use a Bible Dictionary to see a deeper meaning.) What does it mean to you that you have been redeemed by Jesus?

How is God's love described in the following verses?

Psalm 86:15:

Psalm 136:26:

Zephaniah 3:17:

Romans 8:37-39:

1 John 4:7-8:

As we have looked at Ruth's character this week, we have seen her loyalty and faithfulness to her mother-in-law, and more importantly to the God, Jehovah, whom Naomi served. We have also seen her desire to love and serve other people. Maybe God has been stirring your heart toward a deeper commitment to Him this week.

Ruth's commitment was to leave everything behind — her family, her religion, and her city. It was a decision to leave everything that could have been comfortable and move into the unknown.

What changes do you feel that God may be asking you to make and/or what may He be asking you to leave behind? Are you willing to do so?

As we conclude today, take a moment to write a prayer to God, thanking Him for redeeming you concentrating on what His love has brought to your life and the good things He has done for you.

Cultivating a Heart that Loves

We so often use the word "love" regarding many different things. We love our family; we love our dog; we love the weather; we love tacos; we love God. Doesn't it seem that we carelessly toss that word around? Oh friend! How we need to better understand love, especially in our relationships.

In the book of Matthew, chapter 22, and verse 34-40, Jesus is asked, ""Teacher, which is the great commandment in the Law?" And He said to him, "You shall love the Lord your God with all your heart and with all your soul and with all your mind. This is the great and first commandment. And a second is like it: You shall love your neighbor as yourself. On these two commandments depend all the Law and the Prophets." The greatest commandments – to love God and to love others.

I think we can better understand love when we can see what Jesus has done for us. Just as Boaz redeemed Ruth, so Jesus is our Kinsman-Redeemer. Looking back at Isaiah 61 only (see page 65), here is just a small list of what He is able to do for you.

- He is able to heal your broken heart.
- He can set you free from guilt and burden.
- He will give comfort to your aching heart.
- He can fill your heart with joy.
- He adorns you with white robes of righteousness.
- He places a crown on your head as His bride, His chosen one.

And that is just from a few verses of scripture! There is SO much more.
He loves you so much and wants to shower you with His blessing!

If you are not experiencing this kind of freedom in your relationship with Jesus, what is it that is keeping you from it? Ask God today to show you and learn from Ruth. Her job was simply to ask her redeemer to work on her behalf and then to sit down and let Him do His job. Your Redeemer longs to set you free from whatever it is that has you in bondage this morning.

He is ready to give you a life that is full and filled with His blessing. Are you ready to receive it? Are you ready to be still and let Him do His work in your life? Are you willing to submit to Him? If so, then be prepared to sit back and watch Him work!

Would you be willing to offer this prayer of commitment to God in response to Ruth's example?

"Lord, where You want me to go, I will go; where you want me to lodge, I will lodge; Your people will be my people and as my God, I want You to be supreme over every aspect of my life. Where you want me to die to self, I will die. Lord, I am all Yours. I bow and submit myself before You. Do whatever You want in and through my life. All I need is You."

If you are willing, write a prayer of commitment to the Lord below:

Additional Notes:

LESSON FOUR

Esther
a heart that waits

A HEART AFTER GOD

When our girls were young, we worked at teaching them to be patient. I can remember repeatedly reminding them to be patient, and then asking, "What does 'patient' mean?" and hearing their little voices answer, "It means waiting quietly." I'm not sure that Webster would agree with that definition, but I do believe that God wants to cultivate in us a heart that is willing to wait for Him and accept His timing.

As we study Esther this week, we are going to see a woman moved into the palace by the providence of God and given a place of honor as being chosen by the king to be his wife – Queen Esther. And while laws governing her actions in approaching the king were limiting, Esther waited for the perfect timing to enter the king's presence and express her fear over an edict that had been issued that could have led to her death.

Esther does not cower in fear but seeks God's wisdom and holds her tongue until the perfect timing and circumstances are in place. She demonstrates to all of us how to have great patience and how to trust God to act. She is a strong and powerful woman, and we have much to learn from her.

Day One
Introduction & History

Esther's story takes place somewhere between 483 - 473 B.C. when the Persian empire basically ruled over the entire known world. The heartland of Persia was to the east of the Persian Gulf (modern day Iran), but the Persian territory stretched far beyond, into Greece, Egypt, and Asia. Most Jews were living near the Persian epicenter however, rather than in Jerusalem at this time, as they had been taken into captivity many years before and were working under slavery in the capitol cites of Persia.

While we will not go deeply into the history of the Jewish nation, at the death of King Solomon in 931 BC, Israel is split into two divisions - the Northern Kingdom (which is referred to as Israel and comprised of ten tribes) and the Southern Kingdom (which is referred to as Judah and is comprised of two tribes).

These kingdoms begin falling away to the negative influences around them and begin worshipping other gods. In 722 BC, the Northern Kingdom fell into Assyrian captivity, never to be united again; however, the Southern Kingdom fell into Babylonian captivity in 586 BC, but they remained intact and united.

When Babylon was invaded by the Medes and the Persians in 539 BC, the Medes allowed the exiles of the Southern Kingdom to return to Jerusalem. Approximately 50,000 people were led out of Babylon by Zerubbabel, and they began rebuilding the temple in Jerusalem; however, by 450 BC, the remnant had fallen into temptation and fear because there was no wall around the city for protection to keep the Israelites safe from outside influences and threats.

Ezra, who was a priest, was called by God to lead a second group of exiles back to Jerusalem. This second group was much smaller in number (about 2000) than the group led by Zerubbabel, and Ezra's call for repentance in the city was effective and most of the Israelites in Jerusalem returned to worshipping God.

In 444 BC, Nehemiah will lead a third group of exiles back to Jerusalem to rebuild the wall and secure the city. While this information isn't critical to our study today, I think it is interesting to look at how scripture fits together and to better understand the history of our faith.

I do find it interesting that after 150 years of living away from Jerusalem and given the freedom to return to their homeland, approximately 80 years after the release to return, the vast majority of Jews were still in Persia (also known as Babylon). (The name of the area refers to the ruling kingdom at the time, and once Babylon was defeated by the Persians, the name changed.)

Esther's story is found in an Old Testament book, which bears her name, and along with the book of Ruth, Esther is the only other book of the Bible named for a woman.

The theme of the book of Esther is the providence of God, and while His working is evident in the book, His name is not mentioned one time.

Using a dictionary, look up the definition of the word providence, and record it below:

J. Vernon McGee said providence is "the means by which God directs all things-both animate and inanimate; seen and unseen; good and evil-toward a worthy purpose, which means His will must ultimately prevail… Providence is the way God is directing the universe. He is moving it into tomorrow."[9]

In New Testament terms, we often use Romans 8:28 to explain providence. From the Amplified Bible, this verse reads, "And we know [with great confidence] that God [who is deeply concerned about us] causes all things to work together [as a plan] for good for those who love God, to those who are called according to His plan and purpose."

What do you believe about the providence of God?
Have you experienced His hand working and moving in your life in unexplained ways?

Esther's story begins with the ending of Queen Vashti's reign. During an elaborate party, King Xerxes wanting to show off the beauty of his wife to all his nobles and officials. He summoned Queen Vashti to come to him, including instructions to wear her crown. (Some historians believe that she was asked to come wearing only her crown!) The Queen refused to come.

Read Esther 1:13-20 and record what happened to Queen Vashti.

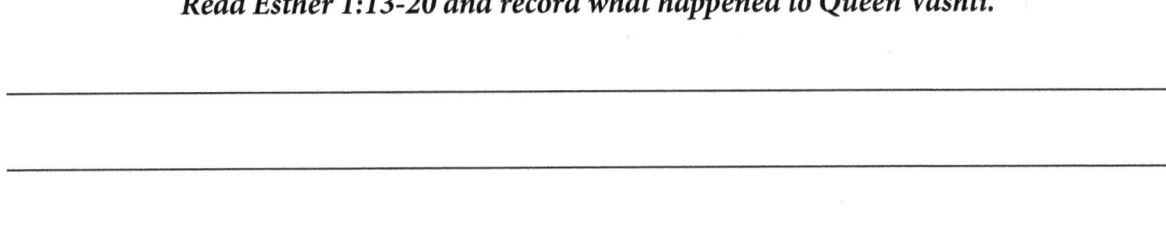

Esther's Story

Esther was a Jewish woman, who was raised by her cousin, Mordecai. Following the divorce of Xerxes and Vashti, Xerxes sent his officials to search throughout Persia for the most beautiful young women. These ladies were taken to the palace, where they were subjected to lessons on etiquette, 12 months of beauty treatments, and provided beautiful clothing and jewelry. Each one waited to be summoned to the king for one night, when he would choose the one he found the most beautifully pleasing to be his wife. (Please note: Ahasuerus and Xerxes are both names for the same king. Ahasuerus is the Hebrew name and Xerxes is the same name in Greek.)

Esther was one of the women chosen for the king's harem and ultimately the one he selectsed to be his queen. This awful plan basically allowed young women to be kidnapped and forced into the king's harem, where they would live for the remainder of their lives. It degrades women to property, discards character, and is wrong on every level.

While it is a disdainful way to find a wife, we do not understand fully the mind of the people in that culture during the time. Esther does not complain about her circumstance, and we see that God's hand was present and moving, even swaying the heart of a pagan king.

Read Esther 2:5-18.
What do you learn about Esther's upbringing in verses 5-7?

Describe how she became queen as recounted in this passage.

All seemed to be well until a power-hungry man named Haman becomes outraged at Mordecai, when Mordecai refused to follow an edict requiring he bow down and pay homage to Haman. (See Esther 3:1-7)

Read Esther 3:4. Why did Mordecai refuse to bow to Haman?

Knowing Mordecai was a devout man,
read the following verses and record what thoughts may have influenced his decision.

Deuteronomy 6:13-15:

I Kings 8:60-61:

According to Esther 3:8-13, what plot did Haman devise to get rid of Mordecai and the Jewish people?

Once Esther hears of the plan, she is devastated. Remember, she is Jewish, and this law will literally wipe out the entire Jewish nation, including the Jews who had returned to Jerusalem, as every occupied land at this time in history was under Persian rule.

Esther desperately needed to speak with her husband, the king, to reverse the decree or find a way to save the Jewish nation; however, the law said no one could enter the king's presence without being invited, even his wife. Walking into his presence uninvited could have resulted in Esther's death, if it angered the king or was seen by his guards as threatening to the king in any way.

Read Esther 5:1-8 and summarize Esther's actions and the king's response below:

Esther plans a dinner party for the king and invites Haman to attend. As they are enjoying the event, the king asks again what Esther would like and rather than giving him a direct answer, she invites them to another banquet the following day, where she will share her wishes. However, as Haman is leaving the banquet, he encounters Mordecai, who does not bow down to honor him. He is enraged and recounts the story to his wife.

From Esther 5:14, what advice does Haman receive from his wife?

That night, the king could not sleep, and asked to have history archives read to him. During the reading, he recalled Mordecai had saved his life years before, and the king realized he had neglected to honor him for that action. In the morning, as Esther's banquet is being prepared and Haman's gallows are being constructed, Haman is called before the king and asked how he would bestow honor on a man with whom the king was well-pleased. Haman, thinking the king wanted to bestow honor on him, envisioned a grand and elaborate public celebration. The king then revealed the celebration was to honor Mordecai and followed Haman's plans in every detail to celebrate Mordecai. Can you imagine Haman's rage and humiliation?

***Haman laments and explains the events to his friends and family.
What is their response in Esther 6:13?***

Before this conversation could end, the king's men arrive to take Haman to the banquet. During the party, the king promises to give Esther anything she desires, and she begs for her life as she is a Jew and because of Haman's evil plot, her fate has been sealed and her execution is imminent.

***The king is enraged at Haman for devising such a wicked and evil plan.
What is the outcome according to Esther 7:7-10?***

Unfortunately, the laws of the day stated that once the king had pronounced an edict, it could not be reversed, even by the king himself. So, to spare Esther's life, and the lives of the entire Jewish race, the king needed to enact a plan to diffuse the first law.

***According to Esther 8:9-12, what did the king's new edict allow the Jews to do
in response to their enemies? What was the outcome according to Esther 9:11-12?***

On the day the edicts were carried out, those who attacked the Jews could not prevail and were defeated. How was this victory celebrated?
(See Esther 9:20-28 for your answer.)

To conclude today's lesson, search the word "Purim" on your web browser and write down any information you find about this celebration and its practice today.

Esther's Character

For Esther, so many things in her life were out of her control. She was forced into a harem, where she would live the rest of her life. Once chosen as queen, she had no access to her husband, unless he summoned for her. Initiating contact with her husband without his consent could have meant her death depending on if her husband was angered by the action. Or, if his guards saw her actions as aggressive toward the king, they could kill her before she ever reached the king.

If that wasn't enough, the responsibility of alerting the king to Haman's evil plan to eliminate all Jews from existence rested on her shoulders. One wrong move could have meant not only her death, but the literal annihilation of the entire Jewish race. So much pressure resting on the shoulders of a young woman! How was it that Esther had such poise, such restraint, and such grace under so much pressure? How was it that Esther was able to not buckle in the face of fear?

Chapter 4 of Esther records how Esther learned of the decree and her response.

What was her response in Esther 4:16-17?

While it is not specifically recorded, Mordecai's demonstration of grief and mourning was customary of the Jews in the day, and Esther's call to fasting was also customary to involve prayer and begging God to intervene to help in the current situation of distress. I'm sure she was praying for the Lord to give her wisdom, asking that He would spare her life and allow her to find favor with the king. And certainly, she was praying for courage to stand before the king.

And then, after three days, she got dressed, and went to stand where the king could see her. She must have looked amazing, because once the king saw her, he offered her anything, up to half of the kingdom. Let's be frank – at that point, I would have lost it! Hungry, emotional, and scared, I would have fallen apart, gushing about how horrible Haman was and allowing my emotions to completely run away from me. I would have reacted in fear, but Esther holds her tongue and waits upon the Lord.

From Esther's response in this situation, there are three attitudes we can take to heart. First, she took her fears, concerns, and her problem before the Lord.

What encouragement do you find in the following verses about casting our cares upon the Lord?

Psalm 69:13:

I Peter 5:6-7:

Philippians 4:6-7:

Secondly, after seeking God, Esther put feet to her faith. One of my favorite phrases in the book of Esther is found in Esther 4:14, when Mordecai reminds her that God may have brought her into the palace of the king "for such a time as this." Esther fasted and prayed. Then, fully understanding the risk of death, she got dressed, and stood before the king. She stood not like a frightened girl, but as the Queen of Persia, with the sole purpose of being noticed by her husband and received into his presence. She didn't react with emotion, nor did she sit and wait for something to happen to her. In Godly wisdom, she responded to her circumstances and stepped out in faith, making herself available to God's plan.

The third character trait we find demonstrated in Esther is patience in waiting for proper timing. Most likely, it was difficult for her to remain poised after learning of the plot and embracing the responsibility of speaking with the king. And while she may have struggled not to let her emotions run away from her, she stayed focused on her goal and trusted God would move.

What are we to do as we wait according to the following verses?

Psalm 27:14:

Psalm 5:3:

Micah 7:7:

Psalm 119:166:

Waiting is not easy. While Esther walked forward in courage, full of trust in God to act on her behalf, her first response was one of fear. Mordecai encouraged her, and she spent time fasting and in prayer for three days before she was strengthened to face her challenge.

When we wait, we learn that God is in control, and Esther seemed to know that. She didn't let her emotions overtake her; she didn't let her mouth run away from her, and she didn't let her fear paralyze her.

What current situation(s) do you need to bring before the Lord?
Are you willing to trust Him to work on your behalf?
Write a prayer below asking Him to give you wisdom and courage to wait for Him to answer.

Day Four
A Deeper Understanding of Waiting

Sometimes the things we bring before the Lord are simple issues, and other times, our cares, worries, and concerns are truly breaking our heart. In those difficult times, waiting for God to answer or relieve our distress can cause us to ache and even question if God really loves us, because if He did, He wouldn't allow THIS to happen. Oh sweet friend, know that God has a purpose when we must walk through deep pain.

What encouragement do you find in the following verses when God seems to be silent in your time of need?

Psalm 34:17-19:

Proverbs 18:10:

1 John 5:13-15:

Why do you believe that we are so quick to believe that God isn't listening, or He doesn't care about our situation when He asks us to wait for His answer?

What do you learn in Isaiah 30:18?

Unfortunately, life is filled with sustained periods of silence, which is hard because when we get into situations that are difficult, we want God to get us out of them as soon as possible! We must remember that God's times of silence are just as significant as when He speaks. In those silent moments, we must remember what we know to be true about God.

What do the following verses tell us about God?
Use a highlighter to mark any words or phrases which are particularly meaningful to you.

2 Samuel 22:3-4:

Psalm 86:15:

Psalm 147:1-11:

Psalm 116:5:

Isaiah 26:4:

God is at work in you – whether you feel Him or not. Remember, God's silence does not mean that God is absent. God is very purposeful in the way that He works in your life, even in silences. We should be using times of silence to get into God's Word and get onto our knees is prayer.

Read Psalm 62:8 and record it below:

Are you willing to pour out all that is in your heart before your God?
You can tell Him honestly how you feel. He already knows everything that is within your heart; you are not going to shock Him with anything you say. But, oh how good it is for our souls to get out feelings, emotions, and frustrations before our God who loves us so!

Day Five
Examining Our Hearts

I don't like waiting. I am a "get things done and keep moving on" kind of person. But I know that God often wants to slow me down and increase my patience and reliance upon Him. Causing me to wait on Him is part of His plan to keep me focused on Him and working on me so I look more like Jesus.

In order to keep my perspective right and my trust centered in God, I have learned to look back and remember the faithfulness of God. I recall the times that God has been faithful to me – in fact, He has always answered, always provided everything I need, always given me strength to endure, and always loved me and given me comfort — always. And He always will. When I remember His faithfulness in the past, it assures me that He will be faithful in the future.

What promises do you find in 1 Corinthians 1:7-9?

*Read the great truths recorded in Romans 5:1-5
and fill in the blanks below from the passage in Scripture:*

- *Since we have been justified by faith, we have _____ with God. (v. 1)*

- *Through faith in Jesus Christ, we have obtained access into His _____ and we rejoice in _____ of God's glory. (v. 2)*

- *We rejoice in our sufferings, knowing they produce _____, which produces _____, which produces _____. (vs 3-4)*

- *Hope does not put us to shame because God's _____ has been poured into our hearts. (vs. 5)*

Because of Jesus and the grace offered to us, we now have access to God, as our sins have been forgiven. We can boldly approach the throne of God and rejoice in the hope of the glory of God. There it is — the hope of the glory of God. Because in our trials, in life, in every moment of every day, at the center of everything is the glory of God. The purpose of trials, challenges, and struggles is that that God would receive glory – NOT that we would find relief!

So, we rejoice in sufferings because as we go through them, God's presence and working is seen. Our trials build our character, which results in hope that does not disappoint, and others recognize God in us, and He receives the glory.

I also thought of Queen Esther as she approached the king, standing in the hallway most likely quivering to see if the King would hold out his scepter to her. We, too, are arrayed in precious robes, as we stand before God, but we do not need to quiver in fear. While Esther put on a lovely royal robe to attract the attention of her king, we stand in the white robes of righteousness, given to us by our Lord Jesus Christ. who lived a sinless life and died in our place for our sin.

God's scepter is stretched out before you, offered to you because He finds you holy and blameless now before Him, not conditional on what you have done, but by His unconditional love and acceptance bestowed upon you through His grace.

Hebrews 4:16 tells us to "come boldly to the throne of our gracious God. There we will receive his mercy, and we will find grace to help us when we need it most." There is no need to cower; or any need to fear – He loves and accepts you unconditionally and you are welcome in His presence!

What is weighing heavy on your heart today? Read Hebrews 4:16 and insert your name below. You can confidently approach God with any burden.

Elizabeth George said this: "Esther's path of wisdom can be yours too. Nowhere in the ten chapters of Esther's story will you find anger or agitation, violence or panic, rashness or reaction. Esther knew that our-of-control emotions do not accomplish God's will…. Relying on God's wisdom enables you and Him together to accomplish His will in His way."[10]

In Esther, we see that one woman, totally surrendered in obedience to God, can truly make a difference. When we have surrendered to Him and are willing to be obedient to Him, He can use us in mighty ways.

*Where has God placed you, and how might He use you "for such a time as this?"
Are you willing to pray about how God wants to use you?*

In your home:

At work:

In your church:

In your community:

Cultivating
a Heart that Waits

While we would love not to encounter any difficult things in our lives, or face any challenges, that is simply not reality. We must expect that trials will come our way. We also must know that sometimes God will rescue us and provide a way out of difficulty quickly, but other times, He will choose to wait.

Sometimes God needs us to learn some lessons in the waiting, as He works on our character, so we can look more like Jesus. Sometimes God has a work to do in another person, and we must wait until God's full plan is revealed and executed, and not get caught up in the piece of the puzzle that affects us.

When those difficult events of life come, remember to wait on the Lord before getting involved. Don't jump in so quickly to try and solve problems and manipulate circumstances on your own. Don't get in a hurry. God is at work in us, in others and in our circumstances.

Read James 1:2-4, 12 and complete the following sentences from the passage below:

Consider it pure_____, my brothers, whenever you face trials of many kinds, because you know that the testing of your faith develops _____.

Perseverance must finish its work so that you may be _____ and _____, not lacking _____.

_____ is the man who perseveres under trial, because when he has stood the test, he _____ receive the crown of life that God has _____ to those who love Him.

When we have trials, we need to know that God is working out something in our lives. He is developing deeper character in us and making us more mature. We don't always understand why. Trials test our faith and stretch us to affirm that we truly believe what we confess to believe. Trials are proof that our faith is genuine! As we endure trials, God is working in us to make us look more like Jesus. Don't run ahead of Him, and don't get impatient as He builds your character. And know that one day, when you are face-to-face with Jesus, he will reward you for your endurance by placing the crown of life on your head.

Read Isaiah 40:28-31 and record the verses below.
Circle any key words that you find that encourage you to wait on the Lord.

Sometimes, just as in Esther's situation, we find that the answer to our challenging circumstances is in the hands and control of another person. Do not try to manipulate circumstances to get your way. Trust that the Lord will open the doors and change hearts that need to be turned.

What do you learn from Proverbs 21:1?

Trust the Lord for enduring patience. Do not let fear cause you to react to your circumstances. Ask the Lord for courage to stand strong and move forward with His wisdom at the appropriate time. He will walk through every situation with you – giving you strength and giving you wisdom.

Additional Notes:

LESSON FIVE

Deborah
a heart that leads

A HEART AFTER GOD

Leadership can be an exciting word to some, as well as a terrifying one. There are people who seem to be born leaders and rise to the occasion when asked to take the role of leading others. Yet, there are others who are more comfortable being behind the scenes and following others who have been placed into authority.

However you feel about leadership, let's approach this chapter by agreeing that all of us are called into a form of leadership in one form or another. Leadership is really about influence, and at some point in our lives, we have all influenced another person – maybe a friend, a child, or a spouse – and that is leadership! You may not have realized it at the time, but influencing a decision about eating Mexican or Italian food for dinner is an example of being a leader!

As we look at Deborah this week, we will look at the heart of a warrior. Deborah is wise and strong – she is a fierce woman! And, whether you realize it or not, you and I are warriors, too. Our enemy is unseen, and none other than the prince of darkness, Satan himself. This week, we will see the spiritual battle we are in and our abilities to withstand his evil and wicked schemes.

Oh, how we need to ask God to develop in us a heart that stands firm, to lead in areas where we are called to do so, and to lead others to Jesus. And we need a heart that will stand strong in battle, because Satan is coming for you – to discourage you, to frustrate you and try to defeat you. But he cannot prevail! Jesus defeated him at the cross and will defeat him again in mighty victory in the future. Just like Deborah, you, too, are a warrior!

Day One
Introduction & History

Deborah was a prophet and a judge in the Old Testament. As a prophet, God called her to speak on His behalf to Israel. As a judge, God called her to deliver Israel in military battle from an oppressing governmental power.

In the Old Testament, the period of time referred to as the time of the judges began after the death of Joshua and ended when Saul was crowned King of Israel, which was a period of about three hundred years. This was a time of great rebellion, and we see the same pattern of behavior repeated over and over. God's children would fall into rebellion by worshipping idols and would lose sight of their belief in Jehovah God.

Read Judges 2:11-13.
How would you describe the Israelites behavior following Joshua's death?

How did God respond to their behavior? (Judges 2:14-15)

How did the Lord provide? (Judges 2:16)

What vicious cycle is recorded in Joshua 1:18-19?

Then people would then repent and turn back to God, only to fall into sin again after a season of time, and the cycle would begin all over again. God's way and provision was to give His people a judge, but the people of Israel were not happy with His provision. Over and over, the people of Israel cried out for a king instead of a judge, and God heard their plea and gave them a king, as they asked.

From 1 Samuel 8:10-17, what were some of the reasons why God did not want to give Israel a king?

Samuel was the last person in the line of the judges of Israel. From 1 Samuel 10:17-24, record how the "coronation" of the first King of Israel took place.

What do the following verses say about Jesus Christ?
1 Timothy 6:14-16:

Revelation 17:14 (the name "Lamb" refers to Jesus):

Revelation 19:11-16 (the rider on the horse is Jesus):

Considering all the verses we covered today, with warnings about kings, God's displeasure in giving Israel a king, and the verses above about Jesus, why do you believe God did not want Israel to recognize any man as king?

Day Two
Deborah's Story

In her role as judge and prophetess, Deborah served as the military leader and ruler of Israel. She was looked to for her wisdom to help decide legal matters and was inspired by God as she poured out His wisdom, knowledge, and instruction as people came to her for help. As a judge, she was also looked to as a spiritual leader as she discerned and declared the mind of God and served as a mediator between God and His people. God called her to execute justice and deliverance. In addition, she was a wife, and many scholars believe she was a mother, too.

During the days of Deborah, Israel did evil in the sight of the Lord, meaning they had turned from Him and were instead living lives in sin. As punishment, God allowed a Canaanite king named Jabin to rule over them. King Jabin's military general was named Sisera, and the Israelites feared the might of his army. The rule of Jabin was cruel and lasted 20 years until the Israelites finally cried out to God.

Read Judges 4:4-5 and record what you learn about Deborah.

In Judges 4:6-7, Deborah reminds a man named Barak of some actions God had asked him to undertake, which he had not yet done. What had God commanded him to do?

What do you learn from Barak's response?
What did Deborah reply and what happened next according to Judges 4:8-10?

To give you a good picture of this ensuing battle, scripture tells us that Sisera had nine hundred iron chariots. To get the materials for those chariots, King Jabin would have had to do a great deal of trading, most likely from Egypt or Syria. This grand army of chariots and the horses it took to drive them implied great wealth and many impressive military connections, neither of which Israel had.

Record what you learn of this battle from Judges 4:14-16.

Victory! The small militia fought valiantly against the mighty army. And the might army's leading general, Sisera – fled! He ran to a camp of people known as the Kenites and fled into the tent of a man named Herber and his wife, Jael, who had an alliance with the king. He believed that he had found a safe haven, but…

Jael and her husband were Kenites, not Jews, but they had connections with the people of Israel. What do you learn in the following verses?

Judges 1:16:

1 Samuel 15:6:

…Jael offers Sisera some nice warm milk and a little nap…

Recount the rest of the story found in Judges 4:20-23.

Deborah | a heart that leads

Wow! The motivation as to why Jael would do this is unknown, but in the providence of God, Jael fulfills the prophecy of Deborah.

Revisit this prophecy found in Judges 4:9 and record it below:

Chapter 5 of Judges is the song of Deborah, which celebrates the victory and thanks God for His deliverance, giving the credit to Jael for killing evil Sisera. And just as a point of interest, it is also the longest poetic composition in the Bible.

What do the following verses say about praising and thanking God?

I Chronicles 16:8-13:

Psalm 30:11-12:

Isaiah 61:10-11:

As we end our study today, write a prayer of praise and thanksgiving to God for the blessings, provision, and protection He has given you.

Day Three
Deborah's Character

The two aspects of Deborah's character we are focusing on are 1.) Deborah as a leader and 2.) Deborah as a warrior. First, as a leader, she was a wise, gracious servant of God and others. She met with the community when they had issues and needed her sound, Godly advice and she immediately agreed to go into battle with Barak, when his confidence of certain victory seemed to waver. That is the foundation of a leader – a servant's heart.

Deborah placed the needs of others above her own needs, which is the foundational characteristic of a servant leader. We also see that Deborah was confident in the Lord and courageous in putting her faith into action.

What do the following verses say about looking to the needs of others and the attitude we should have toward others?

Galatians 6:2:

Romans 12:13:

Ephesians 6:18:

Colossians 3:12:

Not only did Deborah look to others' needs, she was also confident in the Lord and stepped out boldly and courageously in her faith in God.

How do the following verses encourage you to be more courageous?

Deuteronomy 31:6:

Proverbs 3:25-26:

Hebrews 4:16:

Is God telling you to do something or go somewhere? Despite your fears, listen to His call. He has plans that we cannot begin to understand, and hearts and lives may be changed by our obedience. There is an old saying that "God doesn't call the qualified, He qualifies the called."

Doing something out of your comfort zone to glorify Him can be terrifying, but faith was never promised to be easy. What has God been calling you to do? Be bold. Be courageous. Step out in faith for His glory. Never waver in your faith. We may not always know what the road ahead will look like, but we only need to remember that God will faithfully guide us and lead the way.

The third characteristic of leadership I see in Deborah is humility. Ray Stedman, in his book "40 Lessons from an Influential Mentor," said this: "God rarely uses anyone in a great way until He has taken that person through failure. Why? God wants His servants to be emptied of pride and ego, and able to empathize with the least and the last and the lost, the ones He seeks to save…. The humble, the obscure, the self-effacing person – that's the leader God uses."

What do the following verses say about humility?

Psalm 25:8-10:

Proverbs 22:4:

Philippians 2:3:

James 4:6:

James 4:10:

While some of you may not think you are a leader, all of us are in one way or another. While you may not realize it, someone is watching you — how you respond to situations, how you react to your circumstances, or maybe how you help a sweet older lady across the street. And if you are that older lady, how you thank the one helping you! Someone is watching the way you are living your life, even in the ordinary things, your actions either point people to Christ, or distract others from Him. Oh friend, YOU ARE a leader of someone!

Day Four
A Deeper Understanding of Leadership

Not only was Deborah an amazing leader, she was also a fierce warrior. She walked confidently into battle, knowing that God was with her, and He would give her the victory. We, too, are going to face battles in our lives, especially in the spiritual realm. Our enemy in this battle is none other than Satan, and he is tricky!

Our adversary, the devil, is going to try every trick in the book to try and get us to believe his lies over God's Truth. His name in the Greek means "the destroyer," and that is what he wants to do to us – destroy! He will work to destroy our fellowship with God, to destroy our relationships with others, to destroy our faith, and destroy our reputations. He will try to mislead us in any way possible.

What do you learn in the following verses?

1 Peter 5:8-9:

John 8:44b:

James 4:7:

I am assuming that Deborah walked into battle fully dressed in protective armor, and like her, we need to be fully dressed in the armor that God has given us.

Read Ephesians Eph 6:13-17 then fill in the blanks below:

Take up the _____ armor of God, that you may be able to withstand in the evil day, and having done all, to stand firm. Stand therefore, having fastened on the belt of _____, and having put on the breastplate of _____, and, as shoes for your feet, having put on the _____ given by the gospel of _____. In all circumstances take up the shield of _____, with which you can extinguish all the flaming darts of the evil one; and take the helmet of _____, and the sword of the Spirit, which is the _____ ____ _____.

Read the verses below and record the spiritual truth or insight you see for each of the words which describe the armor God has given you.

Truth

John 8:31-32:

John 14:6:

Righteousness

Psalm 89:13-15:

Philippians 3:8-11:

Gospel of Peace

Romans 5:1-2:

1 Thessalonians 5:23-24:

Faith

Hebrews 11:1-3:

Galatians 2:15-16, 20:

Salvation

Psalm 27:1:

Romans 1:16:

On Day Five, we will look at the Word of God, which is the only offensive piece of our armor. But, as we close this section, please remember that we are told to put on the <u>whole</u> armor – all of it! We don't get to pick and choose pieces that we like and omit those we think we don't need. Anything that we leave off leaves us vulnerable.

God has given us an amazing level of protection against our enemy.
Write a prayer thanking Him for His protection and highlight any specific piece
of His armor that has special meaning to you today.

Day Five
Examining Our Hearts

The last piece of God's armor listed in Ephesians 6:17 is the sword of the Spirit, which is the Word of God – our Holy Bible. This is the weapon God has given to us! If you recall the story of Moses and the Israelites fleeing Egypt in Exodus 14, they stood before the Red Sea, watching the magnificence of the Egyptian army at their heels with no place to go. And Moses said, "Do not be afraid. Stand firm and you will see the deliverance the LORD will bring you today....The Lord will fight for you; you need only to be still."

Did you catch that? The Lord WILL fight for you — you need only to be still! God has equipped us perfectly for the Christian walk. He must be the authority in our lives every moment. We put on all the armor that He has given us, and then we stand and let Him fight for us.

What do you learn about the Word of God from the following verses?

Psalm 18:30:

Hebrews 4:12:

2 Timothy 3:16-17:

In looking at Deborah, you may not identify with her as a leader, but we should all look to her example as a warrior, because like it or not, Satan is coming after you and me. He wants to destroy your relationships and your confidence in God, and he wants to destroy the relationship that others could also have with Christ. There are spiritual forces of darkness in our world, and Satan is on the move, trying to do anything to cause us to stumble or to doubt.

Sometimes, he comes at us like a lion, and we can hear him coming, growling, and roaring, and we are prepared. Other times, though, he is disguised as an angel of light, and his attack is subtle and catches us off guard. He wants to confuse what we know about Jesus by causing us to doubt God, adding distortion to His Word, and denying what God has said.

All of us will be involved in spiritual warfare during our lives, as Satan comes against us and attempts to get our attention and affection off God and onto our problems, worries, frustrations, etc.

What encouragement do you find in the following verses?

Psalm 27:1-4:

Psalm 121:

Proverbs 30:5:

Sometimes it is easy to forget all that God has done for believers in Jesus Christ. Through His death and resurrection, our sin has been completely paid for and full forgiveness is ours. In addition, we have the promise of living in Heaven for eternity. Read Ephesians 1:3-14.

Record some of the additional blessings that God has lavished upon you as one of His children.

It can be scary to step out and do what God is asking you to do and leadership and serving God can be lonely. How do the following verses encourage you?

Romans 15:13:

Philippians 4:6-7:

2 Corinthians 12:10:

Colossians 3:14-17 provides a list of the qualities a good leader should exhibit in their service. What characteristics are in this list? Which of these characteristics would you like to ask God to develop in your life?

Cultivating
a Heart that Leads

Sometimes, Satan's distortions and lies about our worth to God are so loud and confusing, so here's some remarkably simple advice:

Take that negative thought your having about yourself…

> the "I'll never measure ups"
> the "I'm a failures"
> the "I'm not good enoughs"

…and then add the phrase "because I am a child of God." If the message is the truth from God, the phrase will make sense. If it is a lie from Satan, it will not.

For example, one of my biggest struggles in my life is insecurity. Recently, I had a terribly busy morning, and stopped by a restaurant to pick up a to-go lunch order and hurry home. While there, I saw some of my friends at lunch together—a lunch I wasn't invited to. I was hurt, and my thoughts just started swirling. The loudest thought I had was, I must not be very good company, and they left me out.

Now tack on the phrase, I'm not good company, and they left me out because I am a child of God." Doesn't make sense, does it? So where did that lie come from? Yeah … Satan trying to get at me!

Actually, what had really happened was they had been at a meeting I was invited to attend, but I was unable and declined. Then, I completely forgot it was happening. Following the meeting, they decided to get lunch afterward—no premeditation not to include me, not leaving me out of the lunch, nothing intentional in not inviting me. In fact, had I been able to attend the meeting, I would have been at the table! But boy, didn't Satan love having a field day with me.

What are you struggling with today? How does the phrase, "because I am a child of God" make you feel? Do you realize that you are loved so perfectly by an amazing God?

Satan is active in our world today and every day. First John 4:4 tells us that Jesus is greater in us than Satan is in the entire world. When we allow His to be our strength and trust Him to win the battles we face against Satan, we <u>will</u> experience real victory!

Additional Notes:

LESSON SIX

Mary & Martha of Bethany
a heart that worships

A HEART AFTER GOD

I am an only child, but always wished I had a sibling. So, watching the interaction between siblings has always been fascinating to me. I have loved watching my own daughters in their relationship with one another and how they interact.

This week, as we delve into the topic of worship, we also we see the connection between faith and works. Our Christian life is centered, grounded, and founded in faith, which is dependent on the work of Jesus Christ on the Cross as payment for our sin. Our only part in salvation is our acceptance of His gift and His grace.

But, as a reflection of that grace, as our outpouring of our gratitude for all that Jesus has done and as evidence of His saving grace in our lives, we should be demonstrating our faith by our good works. Because when our focus is on Jesus, our service brings Him glory and builds up of our brothers and sisters in Christ. This week is a fitting example of both. Martha is our example of working and serving, and Mary our example of faith.

I have been to several Bible studies on these sisters, and the question always comes up, "Are you a Mary or a Martha?" I have always felt that being a Martha is a bad thing. As I identify with Martha more than Mary, I sometimes feel reluctant to admit that. I hope this week we will see that being a Martha isn't all that bad. And, quite honestly, there's a little of Martha AND a little of Mary in all of us!

Day One
Mary & Martha's Story

These sisters are mentioned three times in Scripture. They lived in a city called Bethany, which is about two miles from Jerusalem and will become a center of activity in Jesus' last days. Mary and Martha also have a brother named Lazarus, and scripture tells us that Jesus deeply loved this family.

Read the stories of Mary and Martha.
What thoughts stand out to you in each story?

Luke 10:38-42:

John 11:1-44:

John 12:1-11:

Mary & Martha | a heart that worships

I believe that the story of the two sisters in Luke may be the most familiar. From the story, the family is entertaining Jesus and his followers in their home. Martha, who is remarkably busy in the kitchen, has become frustrated at Mary for not helping her. Mary is sitting at Jesus' feet, listening to Him speak and drinking in every word. Martha asks Jesus to tell Mary to help her out; instead, Jesus rebukes Martha and tells her Mary has chosen better. Ouch.

In the second story in John, we learn that Lazarus has fallen ill, and the sisters send for Jesus to heal him. Because Jesus tarries for four days before going to Bethany Lazarus dies. In this story, we see a different Martha than the frustrated kitchen worker. We see her eager to be in Jesus' presence, full of faith in His power. But also mourning because her dear brother had died.

Look back at John 11:25-27. What amazing statement of faith does Martha make?

In the next verses, she encourages Mary to spend time with Jesus, who once again falls at His feet. While Mary's response is the same, Martha in this passage has a different heart.

The last passage is right before Jesus' crucifixion. This time, we are in the home of a gentleman named Simon, the leper, who we can assume is a former leper whom Jesus has healed, and Simon is now whole. Jesus is with his disciples, and Martha is again there serving. And we read the beautiful story of Mary pouring expensive perfume on Jesus' feet and wiping them with her hair.

Compare Luke 10:40 with John 12:2. In Luke, we see Martha distracted with busyness. And in John, there is a simple statement that says she served others. The Greek word for "serve" means "to serve" but also "to minister," and I believe Martha was more concerned with ministering to others in John than distracted with the tasks as she was in Luke.

What do you believe made the difference in her attitude?

Looking at these two sisters, which of them do you relate to more and why? What shortcomings do you see in these women? What are their strengths?

These are three stories of these amazing sisters — Martha showing us how to serve and Mary how to worship. Actually, I think both ladies are showing us how to worship! In the first story, Martha has the wrong heart and is working just for work's sake, but in the last story, I believe her service IS her act of worship.

Read Romans 12:1-2 and record below what this says about worship.

Day Two
Martha's Character

I think Martha often gets the bad rap; after all, she was the one who was rebuked by Jesus. And I can't think of anything worse than a Holy Jesus spanking! But honestly, isn't she like a lot of us? How often do we get so busy with the chores and the daily routine of life, that we totally miss Jesus? We need to be mindful when our calendars fill up with events and activities, because our busyness can be a hinderance to our intimacy with Jesus.

I find that sometimes I get so busy serving Jesus, thinking that Jesus needs me to be working for Him, when really, I am in desperate need of His work on my behalf. Rather than fixing our gaze on the importance of Christ's work for sinners, we think too much in terms of what we can do for Him. John MacArthur said that "pride can corrupt even the best of our actions... The moment [we] stop listening to Christ and [make] something other than Him the focus of [our] heart and affection, [our] perspective [becomes] very self-centered… even [our] service to Christ [can become] tainted with self-absorption and spoiled."[11]

Take a moment and imagine Martha in a modern-day kitchen. What sights and sounds do you imagine coming from the kitchen to try and get attention and sympathy?

I think Martha had the gift of serving and used in the proper way and with the proper attitude, that gift could have been used to bring God glory and to meet the needs of other people.

What do you learn about serving from 1 Peter 4:9-11?

I can imagine that kitchen. As the chores piled up and the pressure of being a "good" hostess mounted, Martha lost sight of the Savior, and shifted her focus to herself. My guess is she was alone in the kitchen, and everyone else was in the living room. And she wanted someone to notice how hard she was working and to help her out. We have all been there.

But she gets the rebuke from Jesus. The proverbial "kick in the pants" reminded her that her focus needed shifting, from herself to the Lord and to others. She has been given the gift of service, to be used to build up others in the faith. Everything we do should bring glory to God.

What do you learn from Colossians 3:23?

Following Jesus' rebuke, Martha is different. At Lazarus' death, she makes an incredible declaration of faith.

Re-read John 11:20-28 and write down everything you see that shows Martha is focused on Jesus during this moment.

We see Martha serving others at Lazarus' graveside. She seeks out Mary and encourages her to sit at Jesus' feet. She is truly serving at Simon's house, not just working; she is meeting others' needs and sees them, and not herself. Her focus is on Jesus.

Martha's service had become an act of worship. John MacArthur described it this way, "Martha's service on this occasion was directed at Jesus and was commendable for two related reasons: it was motivated by loving gratitude to Him, and by a desire to generously honor Him in the way she best knew how. ... Like her, all Christians are to be engaged in selfless service ... Although it tends to be overshadowed by Mary's dramatic act of worship, Martha's humble service on this occasion was no less commendable and pleasing to the Lord."[12]

Worship just isn't what happens at a service on Sundays but rather the attitude and position of your heart every day in everything you do.

From the following verses, what should be our attitude in serving?

Romans 12:10:

Philippians 2:3-4:

What has the Lord shown you today about serving Him?

To conclude today, I want us to know that Jesus, while he rebuked Martha, He didn't tell her, "You have chosen wrong." But He did say she could have chosen better. Serving isn't wrong, but it can be done with a wrong attitude and wrong motivation. We should always be focused on Jesus, relying on His strength, and working to reveal His glory and NOT for praise for ourselves.

Day Three
Mary's Character

For the lesson today, we will turn our attention to Mary. Her heart and mind were focused on Jesus Christ alone. Giving Him her full attention, she made worshipping Him a priority in her life, and Jesus tells her and Martha, that Mary has chosen the better thing.

Worship was her choice and is the highest priority for every Christian. John MacArthur said, "Nothing, including even service rendered to Christ, is more important than listening to Him and honoring Him with our hearts."[13] Mary's demonstration of love for Jesus was unwavering. Elizabeth George said, "Are you a fellow lover of the Lord, an uninhibited worshipped of God? Do you seek new ways to show your love for Him? God welcomes the gifts of worship that you bring to pour out at His feet. So, make them lavish! And make them every day! Pour out your love in as many ways as you can…and as often and generously as you can!"[14]

Mary lavishly worshipped Jesus, and Jesus told her she had chosen the better thing. According to the website gotquestions.org,

> *Worship should be reserved for God alone… Praise can be a part of worship, but worship goes beyond praise. Praise is easy; worship is not. Worship gets to the heart of who we are…We must be willing to humble ourselves before God, surrender every part of our lives to His control, and adore Him for who*

He is, not just what He has done. Worship is a lifestyle, not just an occasional activity. …Worship is intertwined with surrender. It is impossible to worship God and anything else at the same time …Worship is an attitude of the heart. A person can go through the outward motions and not be worship… God sees the heart.[15]

Write your own thoughts as to why you believe Jesus is worthy to be worshipped.

There is a story of another woman who anointed Jesus' feet and wiped them with her hair. Most likely, Mary knew of this story and because of Jesus' response to the first woman, she believed Jesus would accept her gift as a demonstration of her love for Him as well. Read Luke 7:36-50 and recount the details of this story.

Day Four
A Deeper Understanding of Worship

"Worship is not the slow song that the choir sings. Worship is not the amount you place in the offering basket. Worship is not volunteering in children's church. Yes, these may be acts or expressions of worship, but they do not define what true worship really is. There are numerous definitions of the word worship. Yet, one in particular encapsulates the priority we should give to worship as a spiritual discipline: Worship is to honor with extravagant love and extreme submission (Webster's Dictionary, 1828).

True worship, in other words, is defined by the priority we place on who God is in our lives and where God is on our list of priorities. True worship is a matter of the heart expressed through a lifestyle of holiness. Thus, if your lifestyle does not express the beauty of holiness through an extravagant or exaggerated love for God, and you do not live in extreme or excessive submission to God, then I invite you to make worship a non-negotiable priority in your life.

We worship God because he is God. Period. Our extravagant love and extreme submission to the Holy One flows out of the reality that God loved us first."[16]

Read 1 Chronicles 16:8-36 and record below all the reasons listed that God is worthy of our worship.

We worship God with a lifestyle of demonstrating an extravagant love for Him and seeking His glory in all we do. Read Hebrews 13:1-16 and record any ways you see of worshipping God, either through service or praise.

So, if we know we are to make worship a priority, then why don't we? First, I think just like Martha, we get too busy with our lives, our responsibilities, and our schedules; and suddenly, there just seems like not enough time in the day. Max Lucado stated very simply we should ensure that "[our] work doesn't become more important than [our] Lord."[17]

I think there is also another reason we avoid worshipping God – a much deeper reason that cuts to our hearts. Sometimes our heart just doesn't want to worship. I was there at the death of my mom. We were standing at her funeral, after she passed away following a two-year battle with cancer. She was an amazing woman of God who served Him as both a Bible study teacher and a professional Christian counselor. She helped so many and wanted to serve Him with every moment of her life. And then, cancer. I thought God would heal her. I knew He could. But He didn't; instead, He took her home to Heaven, where she found healing in His arms, face-to-face.

See, sometimes something comes along and challenges our faith. And, in anger, or bitterness, or frustration, or disappointment, we build a wall between ourselves and God. I remember the morning of mom's funeral service, and the moment came to sing the first congregation hymn in worship; I just couldn't get the words out or the notes out.

As a deliberate choice, I made myself sing. It took getting to the third song we had selected that day, but I chose to worship, despite how I felt. And I remember the release once I did. It was as if my grief spilled out at the altar, and I felt God's healing, comfort, and peace flood into my soul.

My pastor, Gregg Matte, in his book, *I Am Changes Who I Am,*[18] says we can have three reactions to pain:

1. **Bitterness** – which is the most natural reaction. It is finding it hard to believe God would allow pain into your life. When we allow bitterness to take root, it destroys any possibility of worshipping God. Oh friend! No matter what has come your way, find a way to trust God in the midst of the pain, even when you do not understand what He is doing. Do not let bitterness take root in your life.

2. **Bargaining** – which is trying to strike a deal with God. It is trying to manipulate God into doing something for you. It is saying, "If you do this for me, God, then I will serve you." The problem is, if He doesn't honor your request, you withhold your worship of Him. You may think your plans and your ideas are good, but Isaiah 55:8-9 tells us God's plans are much better and much higher than our plans. Trust Him to know what is best and to bring it about in His way and in His plan.

3. **Brokenness** – which is surrendering to His will and resting in His ability to handle the situation. Brokenness will stretch and grow your faith if you trust Him and acknowledge that He is sovereign, even in the midst of the trial. It is choosing to trust Him. It is choosing to worship, even if we don't feel like it.

God is often working in our lives to sanctify us and make us look more like Jesus. What do you learn about this process from the following verses?

Ephesians 4:20-24:

1 Thessalonians 3:12-13:

Hebrews 12:9-11:

What do the following verses say about submitting to God?

Micah 6:8

Proverbs 3:5-6:

James 4:7:

Day Five
Examining Our Hearts

According to John Piper, "Worship depends on a right spiritual, or emotional, or affectional heart-grasp of God's supreme value. So true worship is based on a right understanding of God's nature, and it is a right valuing of God's worth. Of course, his worth is infinite. Thus, true worship is a valuing or a treasuring of God above all things. That would be the closest I am going to give to a definition, I suppose. True worship is a valuing or a treasuring of God above all things."[19]

We must choose to make worship a priority in our lives; however, there can be reasons that make it more difficult to worship or approach God. One of those reasons is unforgiveness. What does the Bible say about it?

Read Colossians 3:12-14 What does God says about forgiving others?

How has a spirit of unforgiveness affected your worship of God?

Another reason we do not feel like worshipping God is bitterness. What does Ephesians 4:31-32 say about being bitter?

How has bitterness affected your relationship with God?

The last reason we struggle with making worship a priority is busyness.
Evaluate how much of your time is spent on the following:
Where might you find more time for prioritizing worship?

Reading your Bible

Watching Television

Prayer

Attending Church

Meditating on Scriptures

Exercising

Reviewing Social Media

Sports Activities

Watching Movies

Playing Video Games

Volunteer Organizations

Calling Friends in Need

What action steps will you take to make worship a prominent activity of your life?

Cultivating a Heart that Worships

So, how can we apply the lesson of these sisters to our lives? First and foremost, we need to choose to make worship a priority in our lives, which really means that we make Jesus a priority in our lives.

<div style="text-align:center">

When our focus is on Him alone…
When our heart is attuned to Him…
When our gaze is solely fixed on Him…

</div>

THEN worship is our response, in gratitude for everything He has done, is and will do, knowing we are nothing apart from Him.

What areas of your life would you like to focus on?

- Do you need to learn to serve others without drawing attention to yourself? Do you need to see your service as ministry and release the desire for others to give you recognition or praise by telling you what a wonderful job you have done?

- Do you need to release control and give yourself in complete abandon to Him, without counting the cost of the sacrifice?

- Do you need to release bitterness and quit bargaining with God, and trust Him in complete brokenness and faith to handle your circumstances?

- Is there someone you need to forgive – a friend, a family member, yourself, even God – for hurting you? A lack of forgiveness doesn't hurt the offender, it hurts you. It is like locking yourself in a prison. If you have a spirit of unforgiveness, is it time to let it go?

Make the choice to worship! Make the choice to recognize that God is bigger; that God is stronger, and that God is worthy of our adoration and praise.

Additional Notes:

LESSON SEVEN

Mary, the Mother of Jesus
a heart that surrenders

A HEART AFTER GOD

If I were forced to come up with one word to summarize the Christian walk, it would be "surrender." I believe it is the single most important response we can have to God. If we want to grow closer to Him, we must surrender. If we want to experience greater intimacy in our relationship with Him, we must surrender. If we want to fully experience the abundant life that we believe is ours in Jesus, we must surrender.

I think that most of us understand God wants us to surrender ourselves to Him — to be willing to be moldable clay in the hands of the Holy Potter, and yet, we are terrified to let go completely. We all like to believe we can sing the song "All to Jesus, I surrender…," but we get to that familiar chorus, and while our lips may be singing robustly, our heart is really saying, "I surrender some." Certainly not, "I surrender all."

In my own life, there are some days that I am truly surrendering all that I have and all that I am. And then days, I'm taking charge myself and handing things on my own and thinking, God better not be asking me to do anything hard, or difficult, or out of my comfort zone. Because I am willing to serve Him with every part of me, until it costs me more than I am willing to give.

Are we glad that Jesus didn't have that same attitude? He surrendered all. He took on the full burden of our sin and your sin and didn't quit when things got too hard. He understands how hard it is for us to let go and offers grace to us. Let it be our prayer that every moment of our lives, we learn to surrender more and more to Him.

Day One
Mary's Story

Mary's story may be the most familiar to us of all the women in the Bible, as we typically hear it every Christmas. Mary was a young, unmarried girl from the small village of Nazareth, and she was betrothed or engaged to a carpenter named Joseph also of Nazareth, whom scripture calls a "righteous man." We know that Mary was a virgin and a devout Jewish girl, most likely around 14 to 15 years old.

In those days, the betrothal process was binding, lasting about one year. If the couple decided for any reason during this period not to continue into the marriage, it required a formal divorce.

So, this young girl was simply living her life and waiting for her wedding day, when the angel Gabriel came to her with news.

Read Luke 1:26-37 and write down any information you find interesting or speaks to the character of Mary:

Record Mary's response to Gabriel from Luke 1:38 below:

That totally amazes me! A young teenager responding in complete surrender to God's will and plan, with seeming joy. Max Lucado said, "If Mary is our measure, God seems less interested in talent and more interested in trust."[20]

While we aren't focusing on Joseph, I think it is important to note that he also trusted God in this situation.

Read Matthew 1:18-25 and record below what you learn about Joseph:

When it was time for Mary to deliver Jesus, the ruler of the day, Caesar Augustus, decreed everyone needed to report to the home city of their tribe to be counted and taxed. And so Joseph and a very pregnant Mary, went to Bethlehem, the home city for those in the line of David (which was the ancestry of both Mary and Joseph).

Read the account of the birth of Mary's child from Luke 2:6-20 and note any details below that you find interesting.

Scripture records several more interactions with Mary and her Son, Jesus. What do you learn from the encounters of Mary and Jesus in the following?

Luke 2:22-33:

Luke 2:45-51:

John 2:1-11:

John 19:25-27:

Today, we have spent time looking at the birth of Jesus. The fact that Jesus loved you and I so much that He willingly left Heaven and came to Earth is overwhelming. He left His rightful position of authority and honor in Heaven, and he chose to come to Earth to be born in a humble manner to a teenage mom. That is the picture of humility. That is a demonstration of love.

Take a few moments to reflect on Jesus' love for you and the willing sacrifice He made so you could have eternal life and peace with God. Record a prayer of thanksgiving below:

Day Two
Mary's Song of Praise

During the time Mary was pregnant with Jesus, her cousin, Elizabeth, was also with child and would deliver a baby named John, who would be born six months before Jesus. Elizabeth's baby would grow to become the forerunner of Jesus we know as John the Baptist. Early in her pregnancy, Mary goes to meet Elizabeth, and the baby in Elizabeth's womb leaps, and Mary bursts forth in maybe one of the most beautiful worship songs. These beautiful words of Mary's Song of Praise, in surrender to God's will in being chosen to carry His Son in her womb, are recorded in Luke 1. She expresses her joy in being chosen by God to be the mother of His child and quotes and summarizes several scriptures.

As we look at her surrendering to God's will this week, I think it is important for us to examine her words in what is known as "The Magnificat." It contains many references to passages in the Old Testament, which shows Mary was well acquainted with the Hebrew scriptures.

Read Mary's Song of Praise, "The Magnificat" found in Luke 1:46-55.
How do you see the following verses reflected in Mary's beautiful song in Luke?
Compare the verses in Luke with the verses below.

"My soul magnifies the Lord, and my spirit rejoices in God my Savior." (vs. 46-47)

Isaiah 61:10:

"For He has looked on the humble estate of his servant." (verse 48)

I Samuel 1:11:

"For He who is mighty has done great things for me, and Holy is His name." (verse 49)

Psalm 111:9:

"And His mercy is for those who fear Him from generation to generation." (verse 50)

Psalm 103:17:

"He has shown strength with His arm; He has scattered the proud in the thoughts of their hearts. He has brought down the mighty from their thrones and exalted those of humble estate." (verses 51 & 52)

Psalm 113:7-8:

"He has filled the hungry with good things, and the rich He has sent away empty." (verse 53)

Psalm 107:9:

"He has helped His servant Israel, in remembrance of His mercy." (verse 54)

Psalm 98:3:

"as He spoke to our fathers, to Abraham and to His offspring forever." (verse 55)

Genesis 12:3:

Day Three
Mary's Character

In looking at Mary's character, I see an overarching theme of trust. She trusted God, and she trusted a good friend in Elizabeth. We are going to look into both aspects in our study today.

First, Mary knew God's Word and was obedient to what it said. We studied Magnificat yesterday which contains scripture reference after scripture reference. Some scholars have even identified over 35 potential references in these verses to Old Testament scripture.

Given there was no written Word of God for Mary to read or if she even knew how to read, how do you guess that she learned so much scripture?

Knowing that Mary came from a devout Jewish family, what do you learn from Deuteronomy 11:18-21?

Most likely, Mary's mother and father were faithful in teaching her in regard to her Jewish faith and holy scriptures. I'm sure she was brought to the temple and participated in worship of God, as the women were allowed. Since we know the Psalms were the songs of worship, my guess is she knew many of the Psalms by heart.

What do you learn about God's Word from the following verses?

Psalm 18:30:

Psalm 119:105:

Luke 6:47-48:

Hebrews 4:12:

Not only did Mary know God's Word, but she was also obedient to it. We see her and Joseph taking Jesus to be circumcised on the eighth day after His birth (Luke 2:21), as required by Jewish law. They returned to dedicate Him at the temple (Luke 2:22) and celebrated Passover in Jerusalem every year (Luke 2:41).

How do you see the obedience of Mary and Joseph demonstrated in the story found in Matthew 2: 13-15?

In addition to her deep trust in God, I also think it is important to note that Mary had a trusted friend. We can't read the story of Mary, and not notice Elizabeth. As soon as Mary receives the news from Gabriel, she hurries to tell Elizabeth the news, and then she stays with Elizabeth for three months. Have you ever thought about who you would go to if you had been Mary? Who would offer you support and not be full of questions or condemnation? Who would believe the best about you, despite the evidence that screams otherwise?

Do you have a friend in your life you can share your heart with?
Someone who knows you inside and out and loves you just the way you are?

This type of intimate relationship is rare; in fact, you may have one friend who is this close. This has always been the hardest type of friendship for me as I had a friend like this in my teenage years, but she found other friends and walked away from our friendship, leaving me hurt and making it difficult for me to want to trust women again.

About 20 years ago, though, God began working with me in healing my emotions, and I longed for a friend to again share my heart. And I began praying for God to give me a best friend. He answered and brought a wonderful woman into my life — well, maybe I should say back into my life. She was my roommate after I graduated from college. We were great friends, and maids-of-honor in each other's weddings, but we lost touch, and went separate ways. Through a long series of God-orchestrated events, we found our way back to one another, and she is my best friend today.

We are honest with each other, challenge each other, pray for each other, and hold each other's secrets. If you are lacking this type of best friend, would you be willing to pray for God to bring someone into your life? Honestly, after the hurt and pain of a past failed relationship, it was such a hard prayer for me — I had to surrender the pain and trust God with my heart. And what I now know of this deep kind of friendship and unconditional acceptance, it was worth the risk!

Write a prayer to the Lord, either thanking Him for the gift of your best friend or asking Him to provide this type of friend to you.

Day Four
A Deeper Understanding of Surrender

So, if surrender was at the heart of Mary's character, how do we get to the place of full surrender to God? Plain and simple, we make a choice. I looked up the definition of "surrender." It is "yielding to the power of another," and isn't that the key to being obedient, yielding to what God tells us to do?

As we look at surrender more deeply today, we will investigate three areas we should be willing to yield to our Lord. The first area is to surrender our time.

Read the following verses and record what you learn about our use of time.

Psalm 90:12:

Ephesians 5:15-17:

James 4:13-15:

Regarding your time, what are some areas you would like to surrender control? What would you like to focus on spending more time?

A few areas that came to my mind for consideration are listed below, but God may bring others to your attention.

- *My dependency on my calendar and adherence to a schedule*
- *How much time I spend with God in reading His Word*
- *How much time I spend on my phone/social media*
- *How much time I spend in prayer*
- *How much time I spend watching TV*
- *How often I make serving others a priority*
- *How much time I spend in worship*
- *How much do I prioritize time at work versus time with family/friends*

Use the lines below to write a prayer of commitment to God in surrendering any of these areas above or others He may have brought to your mind:

Are you willing to surrender your time to Him?

The second area we need to surrender to God is our actions and our desire to be comfortable. God has called us to be holy and set apart. We are to be in the world, but not of it and should be willing to take every action before the Lord in prayer to see if He will allow it as His best for our lives.

Read the scriptures below and record what you learn about submitting your physical needs and body to the Lord.

Matthew 6:25-33:

I Corinthians 6:19-20:

Ephesians 4:1-3:

I Peter 2:9-12:
Use the passage below from The Living Bible for your answer.

"⁹But you are not like that, for you have been chosen by God himself—you are priests of the King, you are holy and pure, you are God's very own—all this so that you may show to others how God called you out of the darkness into his wonderful light. ¹⁰ Once you were less than nothing; now you are God's own. Once you knew very little of God's kindness; now your very lives have been changed by it. ¹¹ Dear brothers, you are only visitors here. Since your real home is in heaven, I beg you to keep away from the evil pleasures of this world; they are not for you, for they fight against your very souls. ¹² Be careful how you behave among your unsaved neighbors; for then, even if they are suspicious of you and talk against you, they will end up praising God for your good works when Christ returns."

Are you willing to surrender your actions and way of life to His purposes?

The third area of surrender we are going to explore is that of our will. The word "will" means "the power of control the mind has over its own actions; the power of choosing one's own actions or asserting one's choice, wish or desire." Surrendering the will is about giving up control.

What do the following verses say about submitting to God's will over our own?

Proverbs 3:5-6:

Mark 8:34-35:

Romans 12:1-2:

Are you willing to surrender control to Jesus?

Surrender involves rest, so we must learn to rest in His presence. Do you realize that the fullness and the completeness of God dwells inside of you. All His power, all His wisdom, all the fruit of the Spirit in completeness are in you through the Holy Spirit. He is complete in us…we just don't utilize all the gifts of God within us because we are not surrendered to Him and letting Him do the work through us.

Instead, we are so busy working, even working for His kingdom, that we do not experience the rest that comes from being in Him. We must totally surrender to God, for Him to be above all else in our lives. It is only then that we can totally experience the benefits of our relationship with Jesus and truly experience joy in our lives.

God desires that we are fully surrendered before Him — giving Him our time, our actions, and our will. We should be willing to give up all our rights to our family, our friends, our strength, our jobs, our church. He wants us to be wholly committed to Him. We surrender, not so that He can take everything away (although He has the right to do anything He desires) but, it demonstrates our willingness to submit to Him entirely and that He is above all everything else to us.

I think for many of us, Jesus is prominent in our lives. The next question is, are you willing to make Him pre-eminent?

Day Five
Examining Our Hearts

Every day, every moment is a new decision whether to live in the flesh or in the Spirit. Let's quit trying to do things for Him and let Him live His life through us. Then, we will have His mind to solve difficult issues; His strength to rely on during the tough days; His heart to love others that He puts in our path. But, most importantly, we will have freedom and rest from trying to live the Christian life. We must learn that trying to live the Christian life cannot be carried out in our own strength. We must let Him live it through us every minute!

Surrender your all to Christ and know that Jesus is enough. He is enough in every single situation. There is nothing that you will go through or endure that Jesus is not enough for you to cling on to and trust that He will see you through. Jesus is enough! If you don't get anything else from the study, hear this: until you find satisfaction in Jesus alone; until you know that He is enough for you, you will never know true joy and find peace in resting in Him. He is enough. Period.

Many years ago, our daughter, Catherine, went to a week-long camp for the first time. I vividly remember going to pick her up after enduring a long week of being without her. I saw several people we knew before we found Catherine, and it was great to see them, but I wanted to see her, so my conversations were halfhearted.

When she finally came running across the camp, I was thrilled! I hugged her; I kissed her; and I thought she was the most incredible camper there! Then, we got in the car to come home, and this sweet little voice from the backseat said, "Hey mom, I didn't brush my hair today." Oh, I hadn't noticed. Then again, "Hey mom, I didn't brush my teeth today." Oh, I hadn't noticed that either.

And as the hours passed on our drive home from the camp, this awful stench began to infuse our car — and it was coming from Catherine's trunk _ the trunk that had been baking in the hot, Texas summer sun for hours before we loaded it into the back of our SUV. She had packed all her life in that trunk — her toothbrush, her hairbrush, her clean clothes, her dirty clothes, her really dirty clothes, her wet towels, her wet bathing suits, all of it continuing to mildew as we drove home, sun glaring through the windows of the SUV, heating up that trunk; but I didn't care — my baby was home!

My instructions when we got home were, "Just leave that trunk at the foot of the stairs by the laundry room so I can clean everything up and get rid of that stench. God woke me up later that night and said, "Hey Marsha, that is what I do for you! I don't care if your hair is brushed. I don't care how many spots are on your shirt. I don't care about the stench of life that is on the things you bring along. Just surrender your trunk at the foot of the cross, because I have the power to make everything clean. Just come here and let me love all over you, my precious child!"

What a great picture of surrender! He knows we can't live a godly, good life in our own strength. He knows we are weak, and tired, and He wants to carry our burden for us. If we will just let go!

What do you fear that God will ask you to do if you completely surrender to His will? What do you fear He will ask you to give up?

How do the following verses help you to make a commitment to Him in total surrender?

Isaiah 53:1-12: (these verses are speaking prophetically about Jesus and His sacrifice for you):

Philippians 2:5-11:

Hebrews 4:14-16:

What do you learn about the character or attributes of God from the following verses, including reasons we should be thankful to Him?

Exodus 34:6:

Psalm 34:4:

Psalm 33:18-22:

Ephesians 2:4-5:

What do we learn about ways we can surrender to God from the following verses?

Philippians 3:8:

1 John 5:2-3:

Cultivating a Heart that Surrenders

Are you willing to surrender even if it means you may need to be broken before Him?

Record Psalm 51:17 below:

Are you willing to surrender your rights? Are you willing to give up things you believe you deserve and to give up control? Surrendering to the will of God isn't an easy choice to make because it involves sacrifices. It is trading in the life and the things you know to be certain now, for uncertainty. Will God ask you to do something that is beyond your comfort level? Will He keep things the same? Only God knows! The question is, are you willing?

- Are you willing to be rejected by others who don't understand your choices in being obedient to what God calls you to do?
- Are you willing to give up trying to work to please God?
- Are you willing to quit depending on your own self-sufficiency?

Surrender is probably the most difficult thing we need to do in cultivating a heart that is like Jesus'. His surrender was to the point of physical death; ours is a death to self. We make the choice moment, by moment, by moment. So, for this moment, will you choose to surrender all?

Then, when you realize in the course of time that you have taken control back from Him and are trying to do things your way, you surrender to Him again, and again, and again. It is the surrendered life that brings us joy and contentment, and it brings us rest in Him.

If you are tired of trying to live a good, godly life in your own way and own strength, why not give it a try?

In looking at all God has done for you; in knowing He is King of kings and above all things; in knowing that He only wants good things for you and has a plan to proper and not to harm you—can you surrender your will to Him today and give up control? Can you trust Him to live through you? Will you allow Him to be pre-eminent in your life?

Write a prayer of commitment to God below:

Additional Notes:

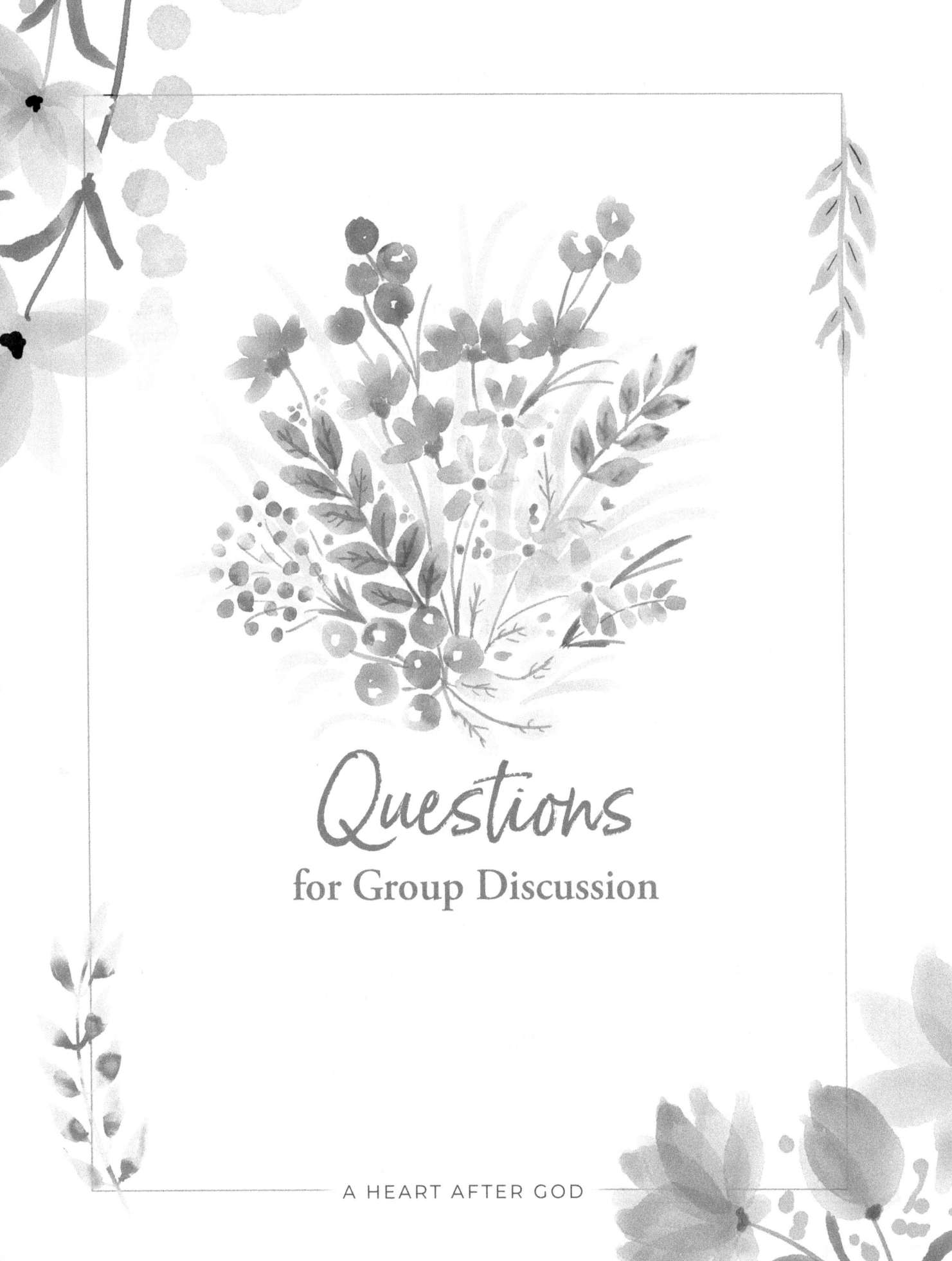

Questions
for Group Discussion

A HEART AFTER GOD

LESSON ONE

Rahab
a heart that believes

1. This week, as you reflected on the introduction for "A Heart After God," what did God show you this week or how were encouraged or challenged from our lesson last week?

2. In the questions for Day One, we read about the faithfulness of God in His promises to Abraham, Isaac, and Moses. What do you believe about God's faithfulness and how have you experienced it in your own life?

3. On page 12, we read the story of the twelve spies. Did you learn anything or find anything interesting from this story?

4. Why do you think the Israelites doubted the promise of God that the land in Caanan was theirs to inhabit?

5. In looking at Rahab's story, what did you find interesting from the questions on Day Two?

6. As we looked into Rahab's character on Day Three, we saw the power of God to transform a life. Printed on page 17 is Rahab's declaration, and the last phrase reads, "…for your God is the supreme God of heaven, not just an ordinary god." In what ways have you witnessed the "supreme God of Heaven" in your life?

7. How does it make you feel to know you are not serving an "ordinary" god?

8. In reviewing Day Four, we were asked to insert our names into several verses. What did God show you by personalizing His Word with your name?

9. On Day Five, we looked at some struggles you might face, and some scripture to remind you of God's truth. What did God show you from the homework on Day 5?

10. In the section on "Cultivating a Heart that Believes," there were four actions points with a scripture associated with each of them. How were you encouraged as you worked through this section?

LESSON TWO

Hannah
a heart that prays

1. You have had time to reflect on last week's lesson on Rahab, did God show you anything that you were able to put into practice this week or brought you encouragement?

2. In looking over the historical introduction (Day One), did you learn anything interesting?

3. What did you learn about Hannah's story from Day Two?

4. Turn to page 35. There is a question asking about a situation where God didn't immediately give you something you wanted. Did anyone have an example for this question, and how God resolved it for good?

5. Day Three highlighted four character traits of Hannah.
 a) What did you learn about her faithfulness by reading her prayer from 1 Samuel 2:1-10?
 b) From the verses from James or Psalms at the top of page 37, what did you see about our speech or where we can run to complain?
 c) In looking at Hannah's love for God, what did you learn from Psalm 63:1-4 or James 4:8?
 d) From the last three verses on page 38, what did you learn about handling frustration, especially frustration with other people?

6. Which of these character traits were insightful or challenging to you? Why?

7. Page 41 of the workbook covered several verses about prayer. What new thoughts did you learn today or what ideas presented encouraged you?

8. From Day 5, what encouragement did you find from Romans 8:26-28 (page 42).

9. On page 45, read Psalm 37:4. What do you believe it means to "delight yourself in the Lord?"

LESSON THREE

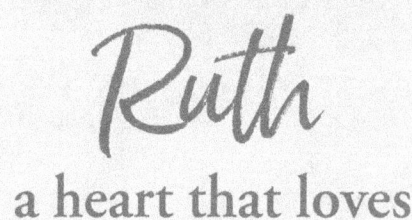

a heart that loves

1. On Day One, we looked at the Introduction to Ruth and that fear may have been a motivation to Naomi's family to flee Bethlehem during the famine. Have you ever made a hasty decision in fear that you have later regretted? How did the verses on page 52 encourage you to not be afraid?

2. What did you learn about the practice of gleaning on page 54?

3. From Day Two, we see Ruth's decision to remain with Naomi. From pages 55-56, what factors do you think led to her decision?

4. What did you learn about the tenderness of Boaz toward Ruth?

5. The concept of a Kinsman-Redeemer was introduced on pages 56-57. What did God show you and how did you express your gratitude toward God for your Redeemer, Jesus?

6. On Day Three, what did you learn about loving others from the verses on pages 60?

7. Second Corinthians 4:6-7 is a beautiful passage. As you reflected on these verses on pages 61 & 62, what did God show you? Do you have any action steps you are planning to implement?

8. On Day Four, we walked verse-by-verse through 1 Corinthians 13:4-7. What did you learn from this exercise?

9. On Day Five, we looked at several verses describing God's love. How were you encouraged by reading these verses?

LESSON FOUR

Esther

a heart that waits

1. From Day One, what did you learn about "providence" by looking at the definition?

2. Have you ever seen the providence of God working in your life?

3. What did you think of the process by which Esther became queen? How do you believe it made Esther feel?

4. Obviously, Mordecai was a devout Jew. What do you think about his resolve not to bow to Haman?

5. Following Esther finding out about the edict to eradicate all Jews, what did you think of her plan to get an audience with the king? What about her plan to expose Haman?

6. How do you think the providence of God worked in the life of Haman?

7. What did you learn about Purim as it is celebrated today?

8. On page 82, we looked up several verses on waiting for the Lord. Psalm 5:3 said to "prepare a sacrifice and watch." While we don't prepare lambs for the temple these days, what are other sacrifices we might offer to God?

9. What encouragement did you find in the verses on page 83?

10. What does it mean to you that you have the invitation from God to pour out your heart before Him?

11. As you examined ways God might want to use you "for such a time as this" on page 88, did you record any action steps or ideas God brought to mind?

LESSON FIVE

Deborah
a heart that leads

1. The period of the judges was a dark time in Israel's history. What did you learn from the first questions on Day One?

2. As the people cried out for a king, God eventually gave them what they asked for. What did you learn about the reasons why God did not want them to be ruled by a king and what you learned about Jesus?

3. On Day Two, we looked at Deborah's story. What did you find interesting?

4. The end questions on Day Two focused on praise and thanksgiving. What did you see about praising God and/or what did you record to specifically thank Him for as you wrote your prayer in the last question?

5. In the questions on Day Three, we looked at several character traits seen in Deborah.

 a) What did God show you in the verses you looked up regarding the attitude we should have toward others?

 b) How were you encouraged as you read the verses about being courageous?

 c) What did you learn about humility?

6. On Day Four, we studied about being a warrior in our spiritual battles. What did you learn about our adversary, Satan?

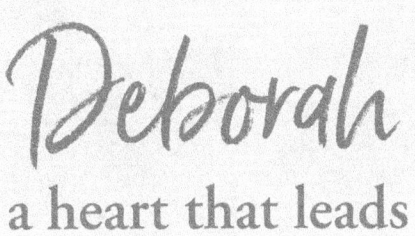

Deborah
a heart that leads

7. The armor God has given us for our protection is grounded in spiritual principles. What did the scriptures you read show you about the following:

 - Truth
 - Righteousness
 - The Gospel of Peace
 - Faith
 - Salvation

8. Day Five centered on God's Word and His ability to fight for us. What did He show you from the first questions?

9. The last questions on Day Five focused on stepping out and serving and the qualities of a good leader. How were you encouraged by these verses?

LESSON SIX

Mary & Martha
a heart that worships

1. As you looked at Mary & Martha's story on pages 113-115, was there anything that stood out to you or anything new that you learned about these ladies?

2. On page 116, how did you imagine Martha in her kitchen?

3. Also on page 116, what differences did you note in Martha from the passage in John?

4. What did you learn from the verses on page 118 about the attitude we should have in serving?

5. On page 119, what were some of the reasons you recorded about why Jesus is worthy of our worship?

6. Everything we do should be an act of worship to God. From the first two questions, what did you learn about reasons to worship Him, or ways that you can worship God?

7. From the commentary on page 123, did you see a reaction to pain that you may be experiencing that is keeping you from whole-heartedly worshipping God?

8. How did the verses on page 123-124 remind you that it is God's work to bring about our sanctification?

9. From page 126, what action steps are you planning on taking to make worship more of a priority in your life?

LESSON SEVEN

Mary...
a heart that surrenders

1. On Day One of our questions, what stood out to you as we read about her conversation with the angel, Gabriel?

2. Have you ever really stopped to think about Jesus' incarnation? That He, who was fully God, agreed to be formed as a man inside Mary's womb, be born as a helpless baby, all the while knowing He would face the pain and agony of death on a cross. As you reflected at the end of Day One, what thoughts or ideas did you thank Him for?

3. On Day Two, we looked at Mary's Song of Praise as recorded in Luke 1:46-55. What did you learn or find interesting?

4. From Day Three, how do you believe that Mary became so knowledgeable of God's Word? Did this spur t you want to know His Word better?

5. What did you learn about God's Word from the verses listed in this day's lesson?

6. How has God used a trusted friend in your life to encourage you?

7. On Day Four, we explored surrendering our time, surrendering our actions/daily living, and surrendering control to Jesus. Which of these is the most difficult for you and why? Did you find any encouragement to let go from the scriptures you looked up?

8. On Day Five, we looked at Jesus' sacrifice and the character of God. How did the verses listed encourage or motivate you to surrender more to God?

Works Cited:

[1]George, Elizabeth. *The Remarkable Women of the Bible.* Eugene, OR: Harvest House Publishers, 2003.

[2]McVey, Steve. *The Godward Gaze.* Eugene, OR: Harvest House Publishers, 2003.

[3]Barber, Wayne, Eddie Rasnake, Richard L. Shepherd, and Wayne Barber. *Following God. Life Principle from the Women of the Bible, Book One: For the Bible-Study Workbook.* Chattanooga, TN: AMG Publishers, 1999.

[4]*Women of the Bible.* Tamar, Daughter of King David — Women of the Bible Bible Gateway Devotionals. (n.d.). https://www.biblegateway.com/devotionals/women-of-the-bible/today, 2024

[5]Unknown Christian. *The Kneeling Christian.* CreateSpace Independent Publishing Platform, 2018.

[6]Bounds, EM. *The Reality of Prayer.* CreateSpace Independent Publishing Platform, 2011.

[7]Wiersbe, Warren W. *A New Testament Study – James — Be Mature.* Colorado Springs, CO: Chariot Victor Publishing, 1978.

[8]MacArthur, John. *Twelve Extraordinary Women.* Nashville, TN: Thomas Nelson, Inc., 2005.

[9]McGee, J. Vernon. *The History of Israel: Ezra, Nehemiah, Esther.* Nashville, TN: Thomas Nelson, Inc., 1991.

[10]George, Elizabeth. *The Remarkable Women of the Bible.* Eugene, OR: Harvest House Publishers, 2003.

[11]MacArthur, John. *Twelve Extraordinary Women.* Nashville, TN: Thomas Nelson Inc., 2005.

[12]MacArthur, John. *New Testament Commentary: John 12-21.* Chicago, IL: Moody Publishers, 2008.

[13]MacArthur, John. *Twelve Extraordinary Women.* Nashville, TN: Thomas Nelson, Inc., 2005.

[14]George, Elizabeth. *The Remarkable Women of the Bible.* Eugene, OR: Harvest House Publishers, 2003.

[15]*Home.* GotQuestions.org. (2013, March 25). https://www.gotquestions.org/difference-praise-worship.html

[16]Kennebrew, Delesslyn A., Stan Guthrie, Dave DeLuca, and with Kyle Wright Philip Ryken. *What Is True Worship?* ChristianBibleStudies.com | Transformed by the truth, 2012. https://www.christianitytoday.com/biblestudies/bible-answers/spirituallife/what-is-true-worship.html.

[17]Lucado, Max. *Ten Women of the Bible.* Nashville, TN: Thomas Nelson Publishing, 2016.

[18]Matte, Gregg. *I Am Changes Who I Am.* Ventura, CA: Regal Publishing, 2012.

[19]Piper, John. *What is Worship? An Interview with John Piper.* Audio Transcript, 4/29/2016.

[20]Lucado, Max. *Ten Women of the Bible.* Nashville, TN: Thomas Nelson Publishing, 2016.

Additional Books from this Author:

Persevere
Everyday Strength from the Book of Nehemiah

While we all love the idea of a life characterized by carefree and easy times, seasons of difficulty, sorrow, and pain are inevitable. In challenging times, we must hold on to truth in order to find strength to carry on.

Persevere is a nine-week study of the book of Nehemiah with practical application for enduring difficulties and standing strong in hardships. It will lead you to explore God's Word by answering thought-provoking study questions from both the Old and New Testaments. The timeless truths in Scripture will help you gain insight and strength to face life's challenges.

- Find encouragement to walk through troubles with God's power.
- Understand the importance of prayer, praise, and worship.
- Overcome fear and anticipate the attacks of the enemy.
- Find rest and peace in God's love.
- Gain new perspective by focusing on and abiding in God's Word.

When life is hard, stand strong in God's truth. You can persevere!

Beyond Blessed
An 8-Week Study of the Book of Ephesians

God has given you so much. You are forgiven, accepted, loved and showered with His blessing both for now and for eternity. You are Beyond Blessed!

Beyond Blessed is a verse-by-verse study of Ephesians that focuses on the believer's great riches in Christ. Not only are we saved by God's grace but incredible blessings have also been poured into our lives through Jesus Christ. This study will help you understand and put to use all God has given you.

- Discover the extraordinary blessings that are yours from God, and learn ways to live every day in light of all God has done.
- Explore God's Word through in-depth study and thought-provoking study questions.
- Claim your true identity and purpose in Him . . . and stop believing defeating lies that hinder your walk with Christ and rob you of joy in everyday living.
- Embrace how you are loved by God.

God has given you so much. You are forgiven, accepted, loved, and showered with His blessing both now and for eternity.

www.ingramcontent.com/pod-product-compliance
Lightning Source LLC
Chambersburg PA
CBHW080639170426
43200CB00015B/2894